IMAGES
of America

DEADWOOD
1876–1976

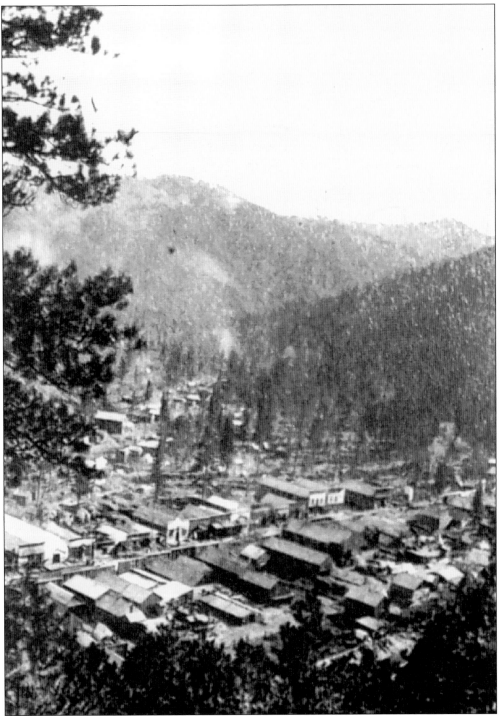

Deadwood was already a budding metropolis in 1877. Many of the crude tents and log hovels have been replaced by side-by-side and adjoining buildings with painted wooden fronts. In 1879, the first fire to decimate the town was caused by an overturned lantern in a bakery. Other fires and natural disasters continued to follow. (Angell photograph.)

IMAGES
of America

DEADWOOD
1876–1976

Bev Pechan and Bill Groethe

ARCADIA
PUBLISHING

Published by Arcadia Publishing
Charleston, South Carolina

Printed in the United States of America

Library of Congress Catalog Card Number: 2005931811

For all general information contact Arcadia Publishing at:
Telephone 843-853-2070
Fax 843-853-0044
E-mail sales@arcadiapublishing.com
For customer service and orders:
Toll-Free 1-888-313-2665

Visit us on the Internet at www.arcadiapublishing.com

*The authors dedicate this book to the historians and photographers who
came before and blazed their own trails by recording and preserving the
history of their own and preceding eras for generations to come. Their
foresight and sense of the importance in doing so are our legacies.*

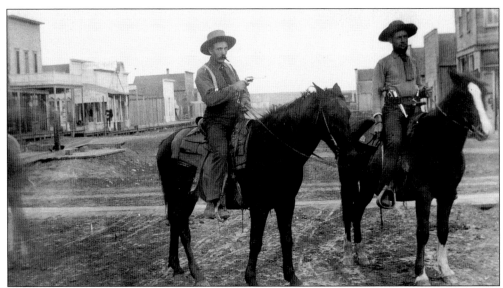

The rough-and-ready cowboys in this *c.* 1880s photograph have just come in off the range and
are looking for a little excitement. They are not in Deadwood yet but are most likely headed that
way. "Duded up" with neckties and clean shirts, the dance halls beckon. Notice the size of the
firearm stuck in the belt of the fellow on the right, just in case. (Collins photograph.)

CONTENTS

ACKNOWLEDGMENTS

This book's existence would not have been possible without the invaluable help of our good friend Dale Lewis. Dale's patience (which was sorely tried several times) and his professional skills and perspective provided us with many of the images needed to complete these chapters.

We wish to thank John and Vivian Fielder for permission to reprint the numerous photographs from the estate of John's mother, the late Mildred Fielder—one of the region's most respected historians and authors. Judi Fleek deserves credit for typing the final text and hundreds of other things. Gene Mincks has been a partner in the early stages by helping to catalog the extensive Bill Groethe and Bell Studio images, which comprise a major portion of this book. Thank you to genealogist Eka Parkison for her willingness always to help locate a missing person or biography. Many pioneering photographers are represented in this volume and are credited where identified. Special thanks and appreciation also go to Bob Burns, president, Homestake Veterans' Association; Dorothy Newhouse, W. H. Over Museum; Laurie Gehner, Homestake Mining Company; Chet Borsch, Galena, South Dakota; Stewart Huntington, *Black Hills Times* and Seaton Publishing Company for permission to reproduce certain photographs; and to Donna Neal, archivist, Devereaux Library, South Dakota School of Mines, repository for the Fielder collection. Postcards are from the author's collection.

Gold prospectors often found the going tough no matter which way they were headed. Grasshopper plagues, famine, the financial panic of 1873—these were all reasons for men to leave their families and join the search for glittering gold and a better life.

INTRODUCTION

In rip-snorting places like Deadwood, gold dust and booze flowed freely while some residents jockeyed for positions of importance within the new establishment of government. Religion among the ambitious was not popular in the earliest days and may have played a part in the killing of Wild Bill Hickok—and the murder of Preacher Smith, a short time later. Wild Bill was viewed with suspicion by some when it was learned he hoped to be hired on as a lawman to clean up the place, as he did in Abilene. Lawman Wyatt Earp also spent time in Deadwood but was content to be a woodcutter and did not put down roots here. But at one time or another, nearly all the famous and infamous on the frontier at least passed through this bawdy spot, 200 miles in any direction from civilization.

Originally called Deadwood Gulch, the lively gold camp comprised the merging of several town sites that sprang up along Deadwood, Whitewood, and Iron Creeks and their tributaries and sported names like Elizabethtown, Montana City, Minneapolis, and so on. Captain Jack Crawford—"the poet scout"—was the first paid newspaper reporter to the Black Hills in early 1876. As a correspondent for the *Omaha Bee*, he first met Calamity Jane in Custer City prior to her leaving for Deadwood with the Utters. Crawford was so amused by her antics, he signed his columns from that period "Calamity Jack."

But Deadwood's and Jane's notoriety and good fortune rose and fell with the times. Fires and floods destroyed entire business sections, and as recently as 2002, raging forest fires licked at Deadwood's hilltops and Mount Moriah Cemetery. For over 125 years, the Homestake Mine in neighboring Lead was the single-most important employer in the Northern Hills. Deadwood folks sometimes tired of their wild and woolly ancestry, but when things were slack, reliving the past was just the economic shot-in-the-arm needed. The return of limited stakes gambling in 1989, with profits set aside for historic preservation, has once more brought Deadwood's past full circle.

Lt. Col. George Armstrong Custer led an expedition of 1,200 men, 110 wagons, and a herd of 300 cattle through the Black Hills during the summer of 1874. Gold was found in French Creek near Custer City, beginning a stampede to the area. Though Custer was much maligned by some for reporting the find, the men also stumbled across proof that gold seekers had searched here at least as early as the 1850s. (U.S. Army photograph.)

One

EARLY DEADWOOD

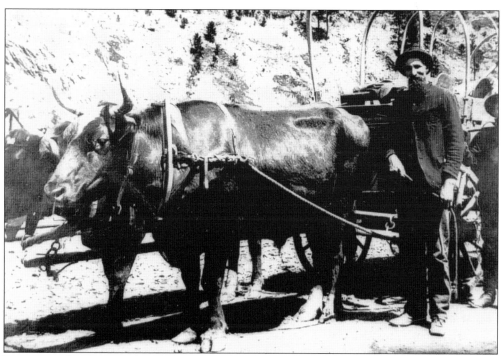

Prospectors heading for the "new Eldorado" find oxen to be quite suitable for travel. Slow and steady, they can pull many times their own weight over all kinds of terrain. The tall man is probably Bill Linn, a former stagecoach messenger. There were not many men in Deadwood who stood six feet, seven inches tall. (Grabill photograph.)

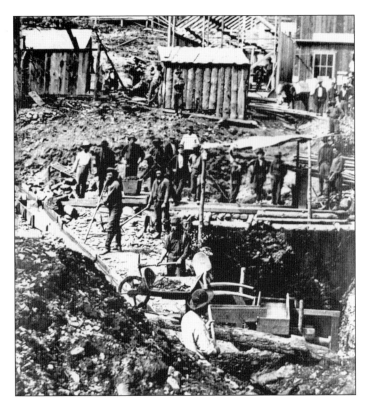

Miners sluice at the site of discovery in the heart of downtown Deadwood Gulch. Sometimes buildings collapsed due to all the frenzied mining activity underneath them. Eager prospectors followed the glitter with little concern about where the trails led. (S. J. Morrow photograph; courtesy Devereaux Library, South Dakota School of Mines.)

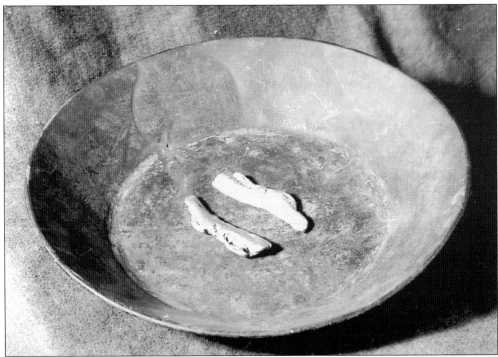

Gold nuggets like these will buy a pretty good "grubstake" for any miner fortunate enough to find even one. Potato Creek Johnny found one even bigger, and it made him famous.

This is the *Pioneer* printing office in Deadwood in 1876. Establishing the first newspaper building in the Black Hills, the *Pioneer* published its first issue on June 8, 1876. Owners Merrick and McLaughlin originally planned to publish at Custer City but followed the rush to the northern Black Hills instead. Early Deadwood and neighboring camps had at least 15 newspapers between them at various times, all founded within months of each other. (Courtesy *Black Hills Pioneer*, Seaton Publishing.)

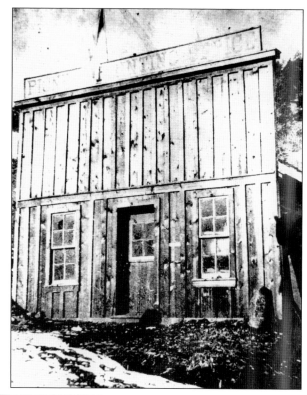

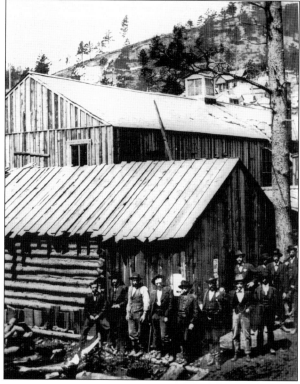

Deadwood's first jail is made of logs and rough-cut lumber like most of its other early buildings. On the lawless frontier, the "lock-up" was a necessary place to keep bad men away from innocent citizens. Before the jail was constructed, miscreants were kept in abandoned mine tunnels. The first jailbreak occurred June 11, 1877, when five prisoners made a run for it.

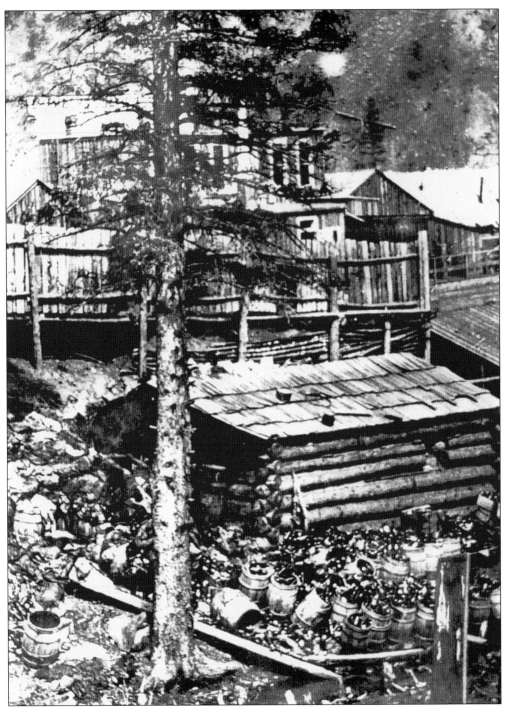

The backside of this saloon shows ample proof of its successful venture. Back then, there was no recycling of materials and little was biodegradable. Saloon keepers Dwyer and O'Dell once slugged it out in a "chair and beer bottle war" before leaving town. Around 1890, Prohibition was in effect around the country, but most of Deadwood was unaware of it (or did not care) and carried on business as usual. (S. J. Morrow photograph; courtesy W. H. Over Museum.)

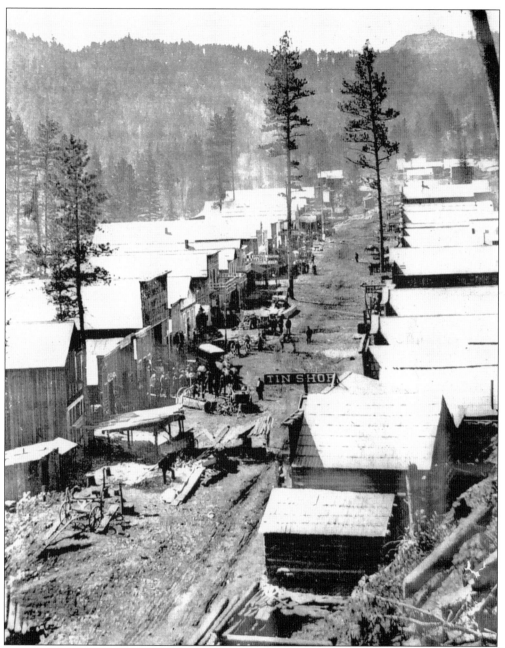

Deadwood is seen here from the west in 1876. Identifiable establishments are a tin shop on the right, and hotels, restaurants, a livery stable, and a dentist's office to the left. The towering twin pine trees add a pleasant touch to the often muddy thoroughfare. On September 5, 1876, the Board of Health—the town's only "official" regulatory body—called for an election to organize the camp of Deadwood Gulch and several adjoining camps into one town. E. S. Farnum was declared the first mayor, and Sol Star was named alderman. Deadwood by mid-October 1876 had a population of 3,000 and 195 businesses. (S. J. Morrow photograph; courtesy W. H. Over Museum.)

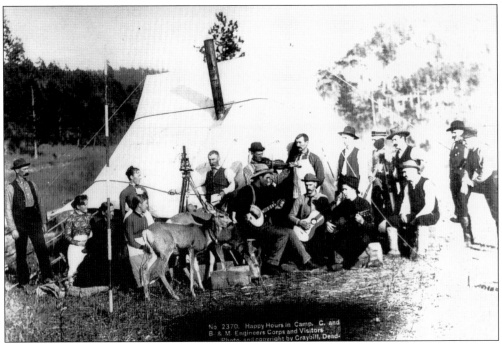

In this 1889 Grabill photograph, surveyors and guests of the B&M Engineers Corps take a break and enjoy a little foot-stompin' music. The pet deer does not seem to mind either. The work the men have undertaken is thought to be for the Burlington Railroad.

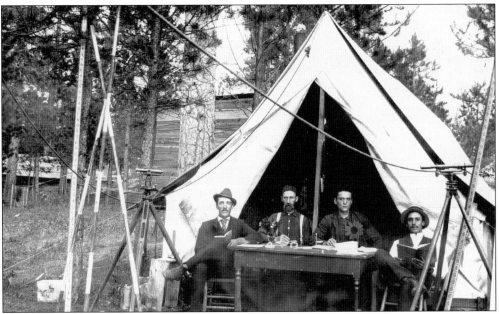

Ready to serve the public in hasty quarters, this intelligent-looking team of surveyors sets up shop near "downtown Deadwood" in 1876 or 1877. Note the fresh flowers on the table. The gentlemen appear to be brushing up on literature while waiting for the next customer. (W. J. Collins photograph.)

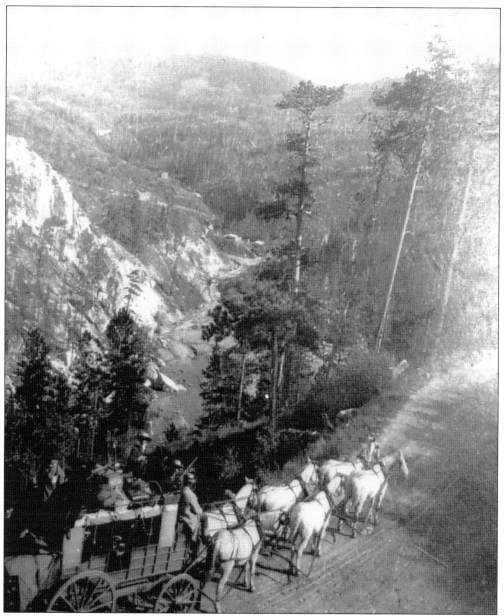

The Spearfish-Deadwood stage enters Deadwood, far down below. To the left is Lime Cliff, with Red Creek running through the gulch. Horses on the six-up hitch were changed at the Halfway House, a noted stage station on the 16-mile route. The coach made its first trip along the treacherous trail filled with precipitous curves in 1882, driven by 37-year-old Harvey Fellows. The run was discontinued in 1896 and resumed in 1903, when it began to carry the mail and even groceries. With loss of the mail contract on December 5, 1910, the stage route was discontinued once again. After logging thousands of miles through hostile country, Fellows was killed in a fall from his old stagecoach at a local celebration many years later. "They had no concern at all about the terror that stalked behind trees and rocks and little hills. It was all a part of the scenery—even when it moved and pulled a gun," wrote Estelline Bennett in her book, *Old Deadwood Days*. (Courtesy Homestake Veterans' Association.)

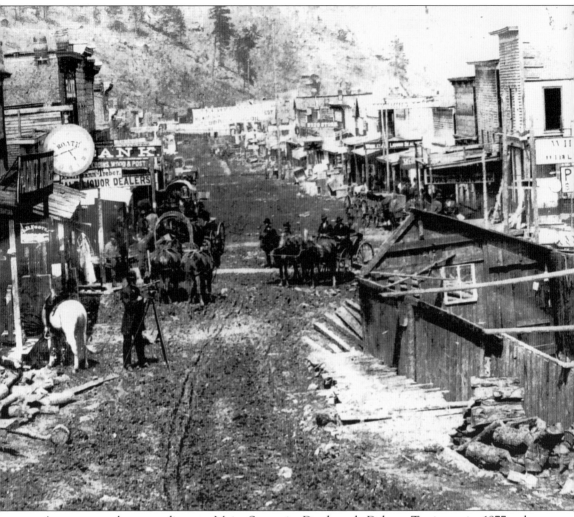

A surveyor takes a reading on Main Street in Deadwood, Dakota Territory, in 1877—the building in the right foreground appears to be going up in the middle of the street anyway. Seen here are Deetkins' Drugstore, the Wyoming Store, Stebbins, Wood and Post Bank, A. B. Foote's establishment, the town clock, and Trebor Liquors—the latter sporting kegs on its roof that can be seen from both ends of town. The banner over the street advertises a brand of lubricating oil. Mail from the outside world arrived on the first stage, September 25, 1876, followed by telegraph service in December 1876, telephones in 1879, and electricity in 1883. (S. J. Morrow photograph; courtesy Devereaux Library, South Dakota School of Mines.)

The notorious Gem Theater was operated by the equally notorious Al Swearingen, a man of "no redeeming qualities." The Gem was a two-story affair—30 feet by 100 feet—and was open day and night. One of the regular "girls" owned a $400 gown with her customers' cattle brands embroidered on it. Swearingen's wife reportedly "customarily wore one black eye and frequently limped." Later Swearingen lost everything and died penniless, as a skid row wanderer.

These gallows were the site of the July 17, 1897, hanging of Isadore Cavanaugh—alias Charles Brown—for the robbery and murder of his employer, Francis Stone, and her pet dog, using a meat cleaver. A large crowd was on hand to see justice done. The platform was erected in front of the Lawrence County jail. More than one hanging occurred in Deadwood, where territorial and federal trials were held.

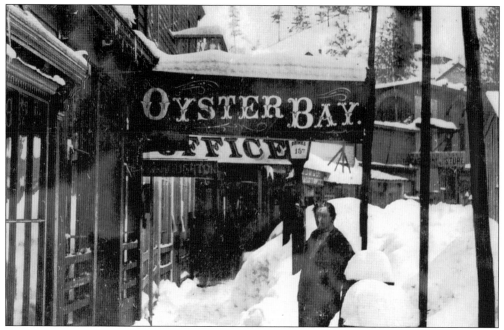

Oyster Bay Restaurant at 10 Lee Street offered drinks for 15¢ according to the sign. It was opened November 3, 1877, by Ed Wardner. Fred Boyle, a "professional oyster cook" from New York was hired and could shell "100 oysters in four minutes." Deadwood snowfalls were often heavy and stayed a long time—eating fresh oysters was a cure for winter blues.

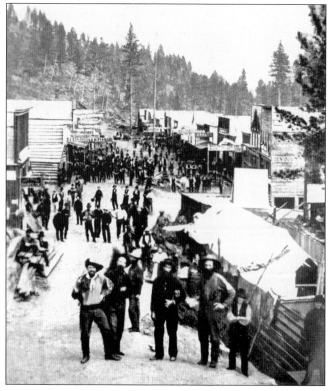

Deadwood in the summer of 1876 was only a few months old, but buildings kept springing up everywhere. The large building on the right is the General Custer House. When Custer met his fate at the Little Big Horn, June 25, 1876, the news reached Deadwood as the town was celebrating its first Fourth of July. Also pictured is the Senate Saloon on the right and Progressive Hall across the street.

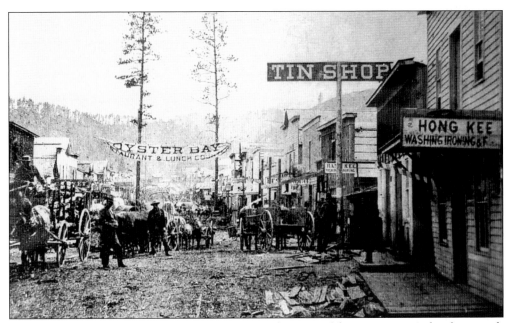

This is Chinatown in lower Deadwood in 1877. Another view of the area is seen in the photograph on page 13. (Note the same tin shop and unusually tall pine trees.) The banner advertises the "Oyster Bay Restaurant and Lunch Counter," and numerous signs represent businesses owned by "celestials of the flowery kingdom," as the Chinese were called, such as the Hong Kee Laundry.

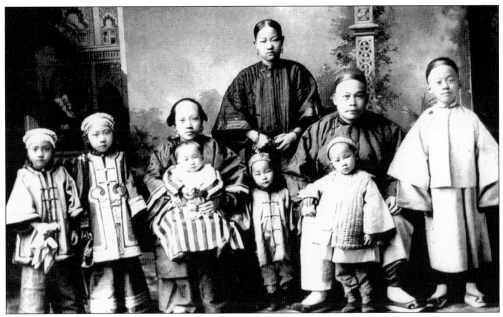

This is the Wong family, also known as Wing Tsue's family. From left to right are daughters King Que Wong and King Shiu Wong; mother, Hal Shek Wong, holding Fay Juck Wong; daughter Fay King Wong standing in front of governess Shu Lin Lau; father, Fee Lee Wong (Wing Tsue); and sons Som Quong Wong and Hong Quong Wong. They represented a wealthy household in 1896.

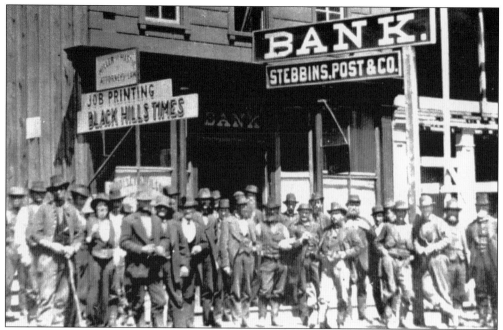

Seen here is Stebbins, Post and Company Bank in 1877, with the boys gathered around for the photographer. The *Black Hills Times* shared office space, as did two attorneys upstairs. Note the building's unusual, wide-plank facade, compared to the rough board-and-batten siding. Construction was completed in just a few days. (Courtesy *Black Hills Pioneer*, Seaton Publishing.)

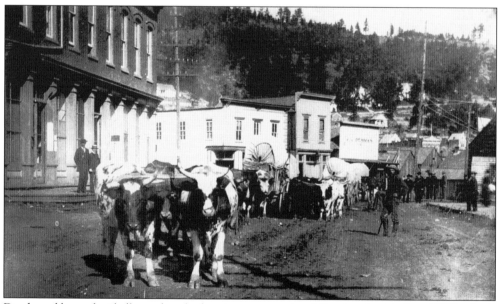

Deadwood has a decidedly modern look to its upper section following the big fire of 1879, which destroyed much of the previous business district. This scene was photographed near Sherman and Pine Streets, showing the old Lawrence County Courthouse at far left. It was razed in 1907–1908. The new and present courthouse was built on the same site. Bull trains ceased to exist when railroads took over.

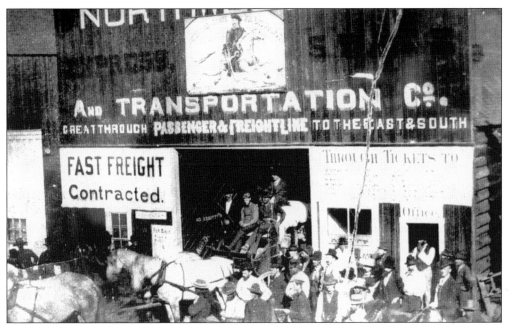

Northwest Transportation Company carried passengers and hauled goods over a vast area, connecting to major cities in the country. The painted sign above the door promotes "the Custer Trail via Bismarck," referring to Custer's 1874 excursion into the territory from Fort Abraham Lincoln near Bismarck, in what is now North Dakota. The company operated in Deadwood from 1877 to 1890, annually accommodating 50,000 people and moving 11 million pounds of freight during that period.

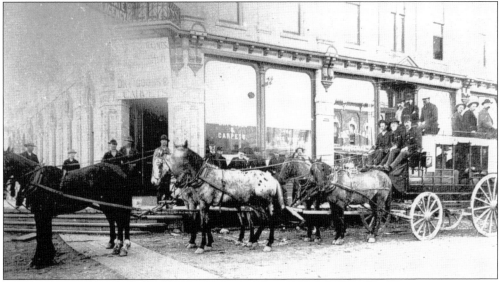

The last stage is seen here leaving Rapid City for Deadwood in 1889, driven by Frank Hunter. This type of vehicle was called a "mud wagon" and was strictly utilitarian. The building in the background was home to a land agency, Haines Dry Goods and Carpets, and John Wallace Groceries. The pair of Appaloosa horses in the center is unusual for the area and time, as they were raised almost exclusively by the Nez Perce Indians in Idaho.

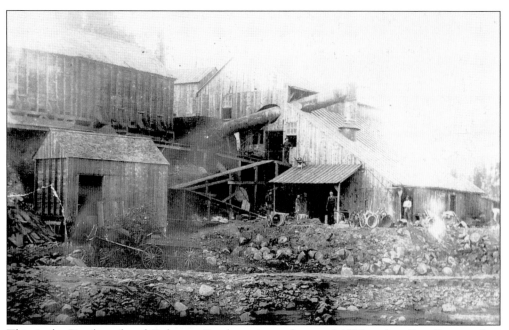

This is the Deadwood and Delaware Smelter, pictured around 1890 with a City Express dray wagon in the foreground. The plant burned to the ground in 1897 and was rebuilt as part of the Golden Reward holdings. It could process 500 tons of ore per day but shut down in 1903 when the cyanide process came into use. (Grabill photograph.)

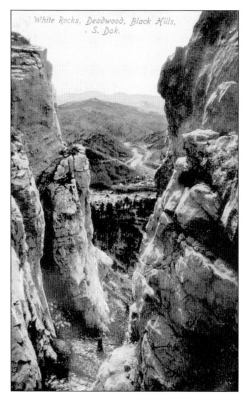

This postcard shows the White Rocks formation above Deadwood. The town was virtually surrounded by these geological landmarks, locally known as Gray Rocks, Brown Rocks, Blue Rocks, and so on. White Rocks, above the present-day rodeo grounds, marked the main entrance to Deadwood Gulch for incoming stagecoaches and other traffic arriving from the east.

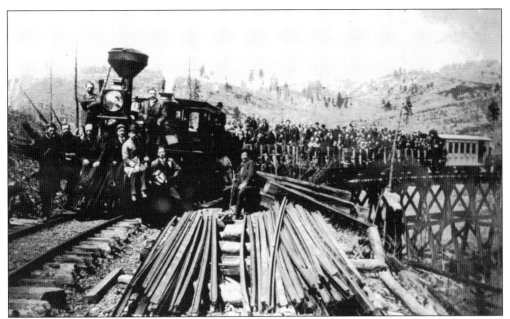

Rails were still being laid in 1885, when the first commercial excursion on the Black Hills and Fort Pierre Railroad took place. The gentlemen packing the cars to capacity are members of the Omaha Board of Trade, who were forced to stand all the way. In the distance, hills look bare—perhaps from commercial harvesting needed to construct and fuel the mines. (Courtesy Homestake Mining Company.)

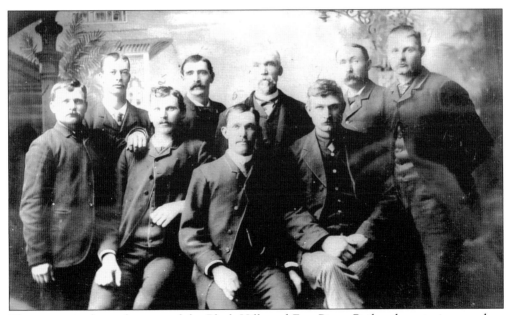

These men made up the crew of the Black Hills and Fort Pierre Railroad pay train run when it was held up October 11, 1888. From left to right are the following: (first row) Tillis Hirbour; Charles Lovier, brakeman; Charles Crist, conductor; and Dell Fockler; (second row) W. W. Sweeney, section boss; Reese Morgan, fireman; John Commisky, engineer; Richard Blackstone, railroad superintendent; and Ben Bell.

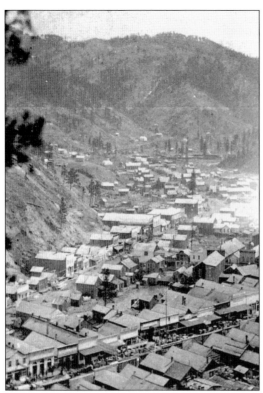

Deadwood's Congregational Church (near this site) was the first church building erected in the northern Black Hills about the time this photograph was taken and was built on bedrock at the foot of McGovern Street in 1877. Painted a drab gray, townsfolk thought it was unattractive. Rev. L. P. Norcross arrived in November 1876 and held his first service in a carpenter shop. The church's first bell came from a Missouri River steamboat. Likewise, the first Catholic services were also held in a carpenter shop.

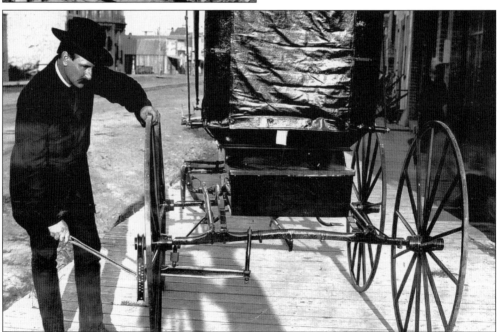

Nobody ever really thought about it in Western movies, but buggies often needed some "adjusting," too. This dapper fellow appears to be wielding his wrench with considerable expertise. Is it a bad wheel or a bent axle? The high-topped beauty seems rather fragile for the rigors of the frontier. (W. J. Collins photograph.)

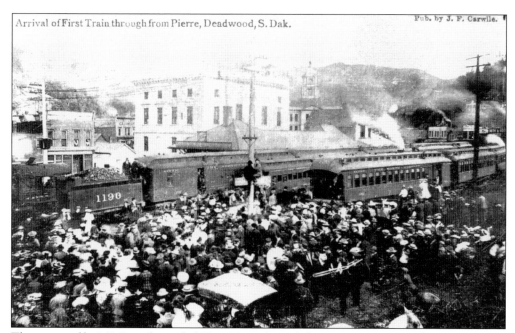

Pub. by J. F. Carwile.

This postcard by J. F. Carwile is titled "First Train through from Pierre, Deadwood, South Dakota." Lawrence County Courthouse, completed in 1908, is visible in the center of the picture. The men climbing the pole are getting a better look.

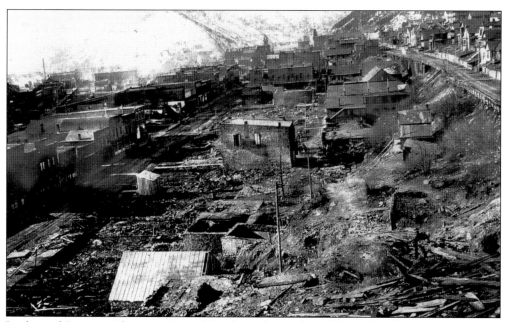

Locke and Peterson Photographers of Deadwood took this photograph following Deadwood's fire of 1894, which leveled two blocks of downtown, including a part of the infamous "Badlands" on lower Main Street. Businesses were rebuilt of stone or brick, and many survive today. The 1879 fire devoured the first ramshackle buildings from the gold rush, exploding kegs of explosives at Jansen and Bliss' Hardware Store, and even burned up the fire department's barn and firefighting equipment.

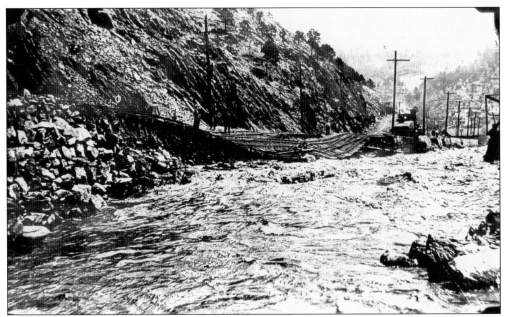

On June 1, 1909, floodwaters wipe out the Burlington Railroad's track in Gold Run Gulch, at the western entrance to Deadwood. Through numerous disasters over the years, Deadwood has managed to recover and reinvent itself again and again, making the town a survivor in the truest sense. (J. Arthur Jobe photograph.)

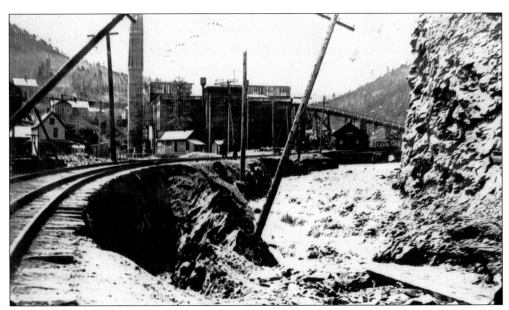

Before reaching Deadwood, the 1909 flood roared through Pluma, just above the junction of Lead and Deadwood. Raging waters subsided as quickly as they came, but replacing the damage took much longer. (J. Arthur Jobe photograph.)

Two

COLORFUL CHARACTERS

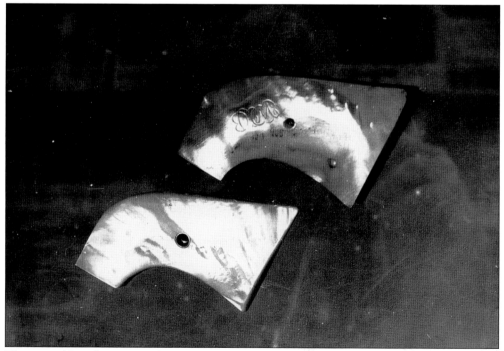

These pearl handle-grips are believed to be from the pair of fancy weapons carried by Wild Bill Hickok and show the engraved initials "WhB" on the inside. They were possibly transferred from one pair of guns to another and were later acquired by a local collector.

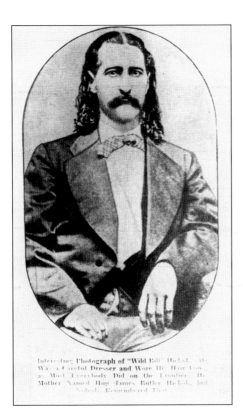

Interesting Photograph of "Wild Bill" Hickok. He Was a Careful Dresser and Wore His Hair Long as Most Everybody Did on the Frontier. His Mother Named Him James Butler Hickok, but Nobody Remembered That.

The legendary lawman, gunslinger, and gambler James Butler Hickok—or Wild Bill—is perhaps the most recognized name in the history of the American West. His good friend Buffalo Bill Cody scouted with Hickok on the plains and said of him that he was a crack shot, a gentleman, and not inclined to brag. (White photograph.)

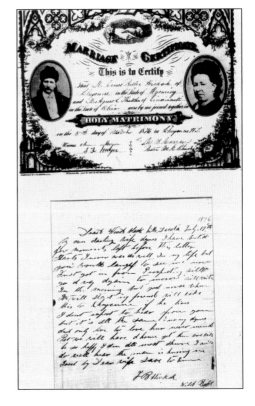

Here is newlywed Wild Bill's letter to his bride, the former Agnes Lake Thatcher—a veteran circus performer and renowned horsewoman—in Cheyenne, telling her of his arrival in Deadwood, dated July 17, 1876. Hickok had hoped to attain wealth in the new country. He wrote, "never mind, Pet, we will have a home yet then we will be so happy." He did not tell her, however, that he had a "presentiment" whereby he would be killed here.

Besides his careers as a military scout, gambler, and gunfighter, Wild Bill Hickok also tried his turn on the stage. Joining the ranks of Buffalo Bill Cody, Captain Jack Crawford, Texas Jack Omohundro, and other frontier contemporaries, Hickok hated it, and the acting bug never bit him as it did the others.

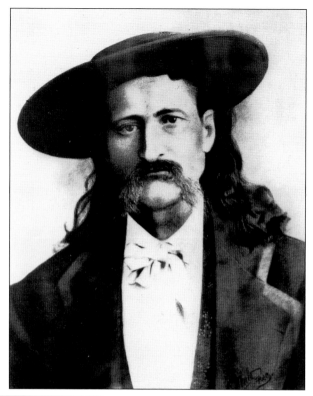

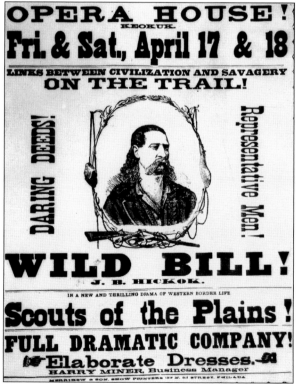

This poster from Keokuk, Iowa, features Wild Bill Hickok costarring with Cody in *Scouts of the Plains*, a vaudeville-type performance dramatized by overacting and a little shooting. Plays such as this with an all-star cast were referred to as "combinations." This show was billed as "a new and thrilling drama of Western Border life." The date of this national tour was probably the early 1870s.

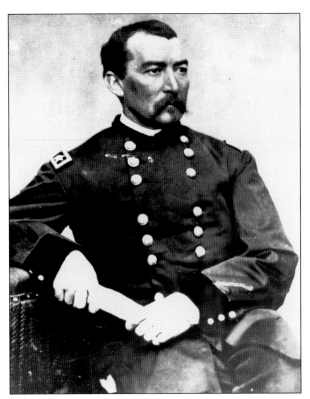

Gen. Phillip H. Sheridan was an officer in the Civil War and later of the U.S. 7th Cavalry in charge of the Department of Dakota. A superior to, and personal friend of George Armstrong Custer, lieutenant colonel and brevet-general, it was Sheridan who ultimately made many of the career decisions affecting the popular but controversial Custer. (National Archives photograph.)

The flamboyant Custer is photographed during the Civil War. "The Boy General" was, at 23, one of the youngest to ever receive that rank. Custer fearlessly led his Michigan Wolverines into several major battles that often turned into victories. History is still unclear regarding the actual events at the Little Big Horn resulting in his death and the massacre of over 200 troopers of the 7th Cavalry under his command. (National Archives photograph.)

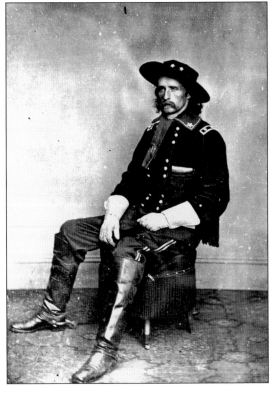

Hailed as a noted Indian fighter, Gen. George Crook committed serious errors of judgment just the same. In better days, Crook City was named for him, but in September 1876, and while chasing hostiles following the Custer disaster, Crook unwisely ordered his supplies shipped on ahead, while his starving men were forced to kill and eat their mounts on this "horsemeat march." (Smithsonian photograph.)

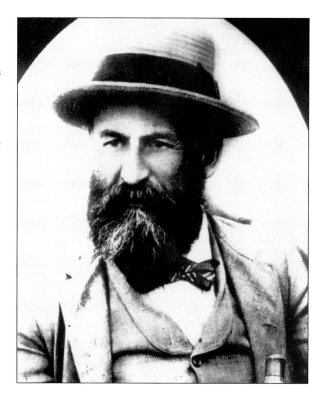

Former riverboat pilot Capt. W. R. Massie sat across from Wild Bill Hickok during that ill-fated poker game of August 2, 1876, that took Bill's life. Assassin Jack McCall's deadly shot passed through his victim's head, and the fatal projectile then lodged in Massie's wrist. Hickok, who superstitiously never sat with his back to the door, did so this time. He was holding aces and eights, since called "the deadman's hand."

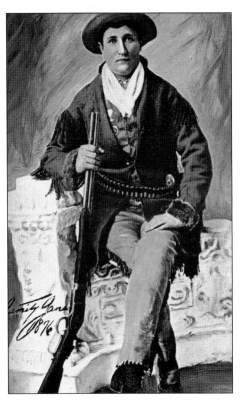

Martha Jane Canary, pictured here, is better known as Calamity Jane. A boisterous drunk who could "howl like a coyote" when on a binge, she was otherwise honest and kindhearted. She nearly single-handedly nursed Deadwood's gold camp through a small pox epidemic, going into places where even doctors would not venture. Calamity Jane was Wild Bill's biggest fan, and she adored him, probably because he treated her with respect—something new to her.

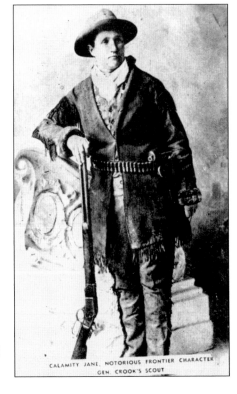

CALAMITY JANE, NOTORIOUS FRONTIER CHARACTER
GEN. CROOK'S SCOUT

Calamity Jane first came to the Black Hills by following a military train from Fort Laramie, Wyoming Territory, in early 1876, dressed as a man. She was discovered but refused to turn back, so she was employed as a "bull-whacker." She could swear with the best of them and was an excellent cook. None who met her ever forgot her.

Dime novels like these from the *Deadwood Dick Library* romanticized feats of Western characters like Calamity Jane, Deadwood Dick, and Wild Bill, making author Edward L. Wheeler—alias Ned Buntline—a wealthy man. Many of these legendary figures owed their fame as household names of the times to Wheeler's publishing efforts.

Deadwood Dick, portrayed as a highwayman-turned-hero, was every boy's idol and every mother's nightmare in the late 19th century. Tales of derring-do stirred up dreams in young hearts that sometimes interfered with doing daily chores or finishing school work on time. There were no less than five men who were recognized as Deadwood Dick over the years.

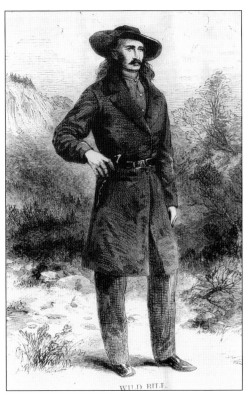

This engraving of Wild Bill Hickok as the "Prince of Pistoleers" shows him with only one weapon instead of the two he was noted for carrying. Hickok once told friends he had no fears as long as he had his trusty gun and "the friendship of California Joe."

California Joe, whose real name was Moses Milner, was a mule-riding Kentuckian who went to the West Coast, eventually working his way through the gold fields of Idaho and Montana. As an army scout, he traveled the plains under several officers and was a personal favorite of George Armstrong Custer. As wagon master, California Joe guided prospectors and settlers to the Black Hills, via the Bismarck Trail, founding his own colony near Rapid City.

Sitting Bull was the Hunkpapa Sioux medicine man responsible for Custer's annihilation at the Little Big Horn. A smallish, stocky man who walked with a limp, Sitting Bull had no use for the white man but said that he would "rather steal from them than kill them." Ironically, he is holding a peace pipe in this photograph and was murdered by his own people as he was resisting arrest. (National Archives photograph.)

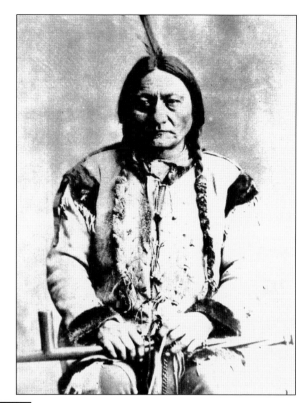

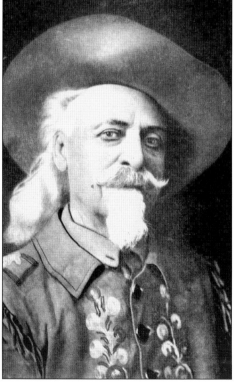

Photographed here is Buffalo Bill (William F. Cody)—army scout, actor, showman, and film director. Cody and Sitting Bull, for a time, traveled together in Buffalo Bill's Wild West Show. Sitting Bull seemed to enjoy show business, and the pair formed a lasting friendship. Buffalo Bill's Wild West Show traveled the world and played before royalty. When the show disbanded in the late 19th century, Cody kept its famed Deadwood stagecoach, which he acquired by a throw of the dice.

35

A practical joker, "Doc" Ellis T. Peirce, came to the Black Hills early, stopping first in the Southern Hills. He was in Deadwood when Wild Bill Hickok was killed and offered to attend to the body. Called the "improvised undertaker," Peirce was not a medical man but did such a good job that Hickok's remains were still intact when his body was dug up and moved to Mount Moriah Cemetery a year later.

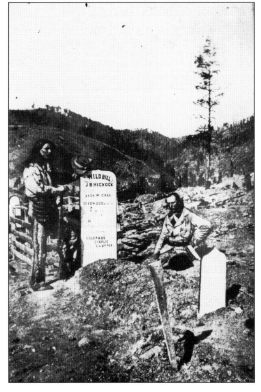

Another traveling companion of Hickok's was Colorado Charlie Utter, who is sitting at the right. He fashioned this fancy headboard for his "pard" at Ingleside Cemetery, Wild Bill's first resting place. Utter led the Colorado-Cheyenne wagon train that brought Wild Bill to Deadwood. Wild Bill lived with Charlie and Steve Utter at their Whoop-Up Camp, where Deadwood's city offices are now located. Hickok's funeral was held at the camp on August 3, 1876.

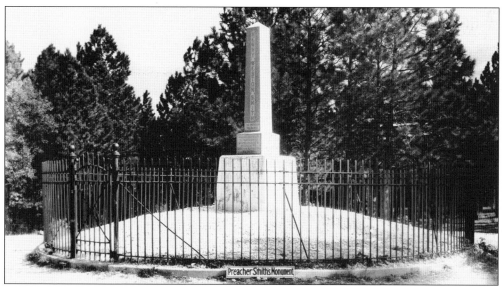

This monument at the northeast entrance to Deadwood was erected in memory of Preacher Henry Weston Smith, who conducted Wild Bill's funeral service on August 3. On August 20, 1876, Preacher Smith left on foot, carrying only his Bible to read a sermon at Crook City. Not far from Deadwood, he was set upon and killed by renegade Indians. Preacher Smith's body was brought back to town on a wagonload of hay. It was one of several atrocities to take place with the influx of settlers to the area.

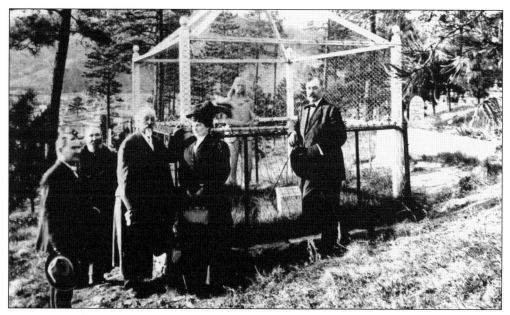

In 1906, Buffalo Bill (third from left) visited Deadwood and paid his respects at the grave of Wild Bill. This sandstone statue of Hickok was created in 1902 by Alvin Smith to replace an earlier one. A cage was initially placed over the Smith figure to discourage souvenir hunters, but the piece was literally hacked to death over the years. The other men pictured are thought to be Col. W. Thornby, Mike Russell, and Matt Plunkett. The woman is unidentified. (White photograph.)

Seth Bullock was Deadwood's first sheriff and U.S. marshal in Dakota Territory. A Montanan, Bullock also engaged in several businesses. He was appointed the first Black Hills Forest Reserve superintendent and was a devoted pal and confidant of Pres. Theodore Roosevelt. In Montana's territorial senate, he helped make Yellowstone America's first national park in 1872. Bullock is pictured here at London's Kensington Palace in 1910.

Deadwood mayor Sol Star had a method of winning elections—his mill frequently gave away sacks of flour to cash-strapped customers he knew could not pay. These accounts were settled in the form of votes at the polls. Teamed with Seth Bullock, the pair operated Star and Bullock hardware stores in several Black Hills locations and raised Standardbred buggy horses that could cover ground quickly.

Considered the best and "nerviest" of the shotgun messengers, Scott Davis's career on top of careening stagecoaches lasted nine years. He was aboard the "treasure coach" during the famous 1878 Canyon Springs holdup, 30 miles south of Deadwood. Homestake Mine used the ironclad stagecoach to carry its gold shipments. In its heyday, the heavily-armed fortress transported nearly $60 million in gold without a loss.

John S. McClintock, pictured here at age 92, was another of the Black Hills' noted stagecoach heroes. He drove the route from Spearfish to Deadwood. In his later years, McClintock turned author and wrote of his memories and experiences in an important historical contribution titled *Pioneer Days in the Black Hills: Accurate History and Facts Related by One of the Early Day Pioneers.*

Cigar-smoking Poker Alice Tubbs was an English beauty who was well educated and came from a good family. When her first husband died in a mine accident, she supported herself by dealing cards throughout the West. A dealer first in Deadwood, Tubbs finally settled in nearby Sturgis, where she relieved Fort Meade soldiers of their money and provided them with female companionship. She had three husbands and seven children and raised a garden, chickens, and dozens of cats.

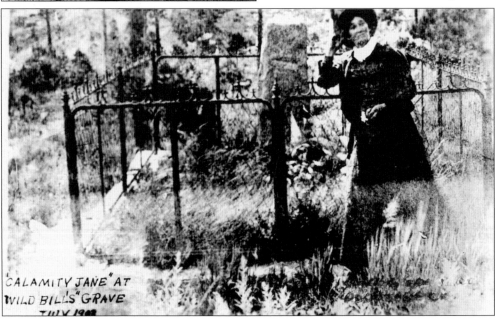

Calamity Jane appears at Wild Bill's grave in this 1903 photograph, taken just two weeks before her own death. She was drunk on this hot day, struggling to get up the steep hill to the cemetery to place a rose on Hickok's grave—"the only man I ever loved." Calamity Jane had the largest funeral ever held in Deadwood, with thousands in attendance, and was buried next to Wild Bill.

40

Three

LEAD CITY

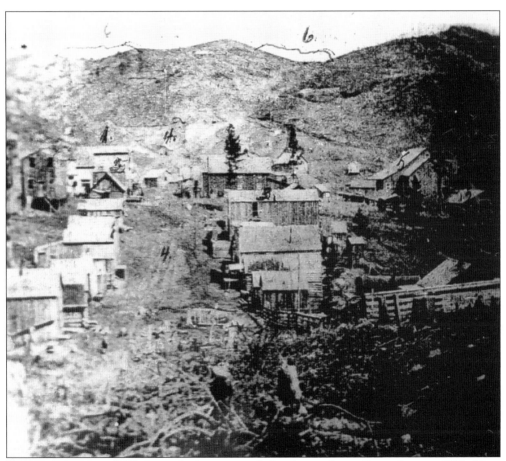

Here is a scene on Mill Street looking toward the future Open Cut, taken in 1876. Main Street crossed the area near the pine trees. Some early businesses included Holvey Drug Store, McCauley's Mill, Jack Gray's Blacksmith Shop, a dance hall, and at least one saloon. (Courtesy Homestake Veterans' Association.)

An exhausted ox team rests in downtown Lead City, Dakota Territory, in this *c.* 1887 photograph. Fred Evans' Black Hills Transportation Company used 1,000 to 1,500 men, 2,000 to 3,000 oxen, and 1,000 to 1,500 mules on its Fort Pierre to Deadwood route. Lead (pronounced Leed) was the Black Hills' largest and most prosperous city for many years. Note the telegraph poles that linked the community with the outside world. (Grabill photograph; courtesy Homestake Mining Company.)

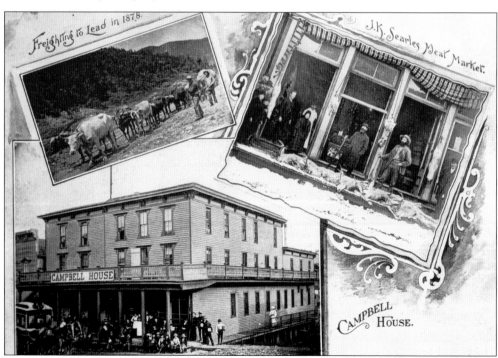

This triple-view promotional piece depicts typical business activity in Lead before the turn of the 19th century. Shown are an 1878 bull train, J. K. Searles' Meat Market, and the Campbell House.

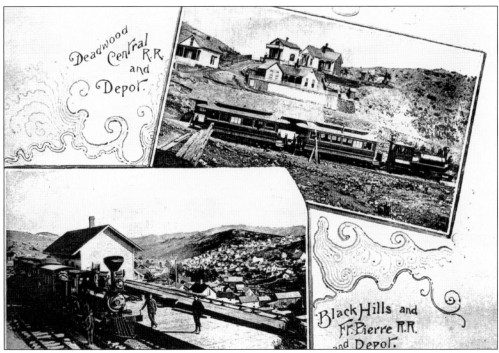

The Deadwood Central Railroad and depot are pictured above. Engine No. 4 pulls up at the Fort Pierre and Black Hills depot, as illustrated in *Souvenir of Lead* published by J. E. Meddaugh in 1892.

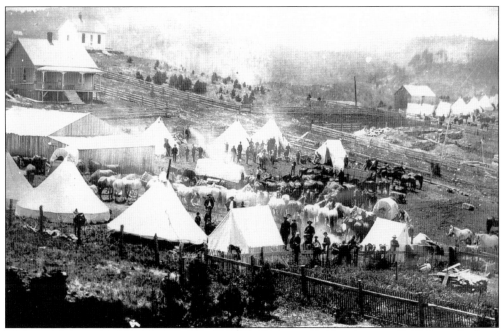

The Grand Army of the Republic convention in 1890 is situated at the top of Mill Street looking south. Local prosperity is in evidence from the appearance of the homes and well-kept farms surrounding the site. (Courtesy Homestake Veterans' Association.)

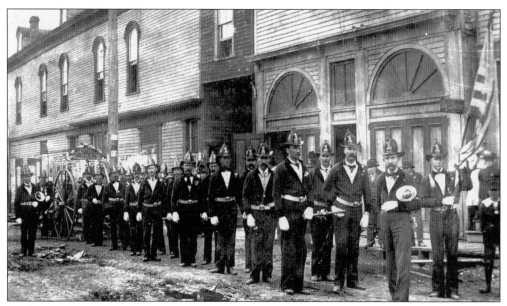

Lead City Hose Company No. 1 is on parade for Memorial Day, 1897, on Mill Street. With leather helmets, white gloves, neckties, and decorated hose cart, the men present a fine turnout. In Victorian times especially, local firefighters were considered a town's most important asset, as they protected neighbors and business districts. Competition between various precincts was keen during holiday celebrations, with each team claiming to be the best.

Lead fire chief Jim Mayo and his associate get ready for a parade in 1915. In the background is the elegant Smead Hotel, which was razed when the ground underneath it shifted. A dozen years earlier, it was Mayo who urged Calamity Jane to pose for the photograph he took of her at Wild Bill's grave (page 40), which was the last picture taken of Jane and was lost or hidden away for nearly a half century.

This photograph looks up Main Street from the northern corner of Mill Street around 1900. On the right is Holvey Drug Store. The prominent turret shape identifies the Miner's Union building. Merchant's Café is also visible. It could be winter, but the lack of overcoats indicates that this could just be springtime in the Black Hills.

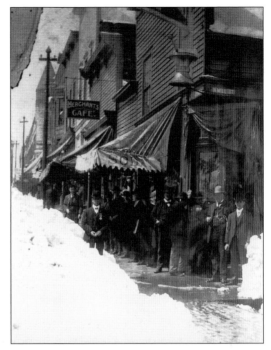

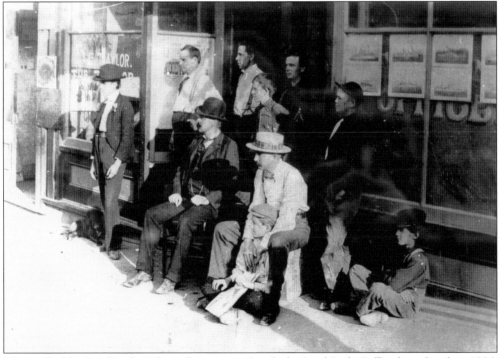

The staff of the *Lead Daily Tribune* (later merged with the *Lead Daily Call*) takes a break in 1886. From left to right, they are as follows: (first row) Madison Ballantyne, Willis Bauer, and Harvey Schmitz; (second row) S. E. "Dad" Crans, Jess Schoff, Morris Powell, Ernie Pease, Joe Keffler, and George Julius (seated at right). The building is across from the old Miners and Merchants Bank on the south side of Main and west of Gold Street.

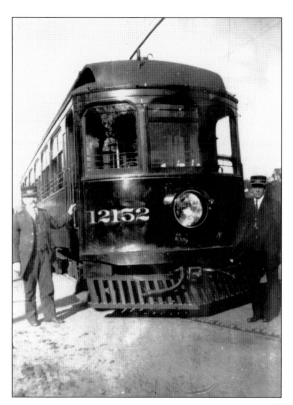

Lead had a modern trolley system courtesy of the Deadwood Central Railroad (later Chicago, Burlington and Quincy) that ran between Pluma and Lead. The 1912 crew of car No. 12152 is Bert Hutton, left, and Charley Barton. Lead was for many years considered the most urban city in western Dakota.

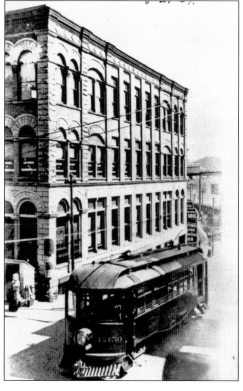

This postcard by J. Arthur Jobe, dated September 21, 1907, shows Deadwood Central Trolley No. 12150 in front of the First National Bank on Main and Mill Streets, where the sinking gardens near the Open Cut were later located. The second floor housed the law offices of Chambers Kellar, and the third floor was occupied in part by the Lead branch of the Elk's Lodge.

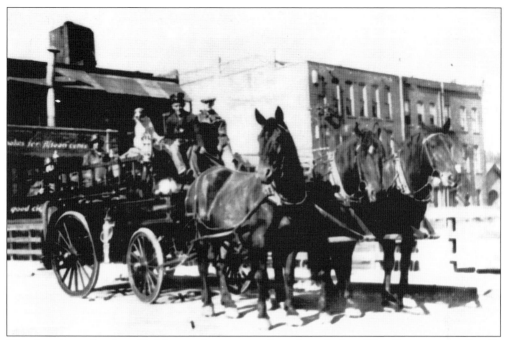

The three-horse hook and ladder unit became a reality when the Lead Fire Department officially became a paid division of city government, around 1914 to 1920. The mascot, no doubt, is just along for the ride.

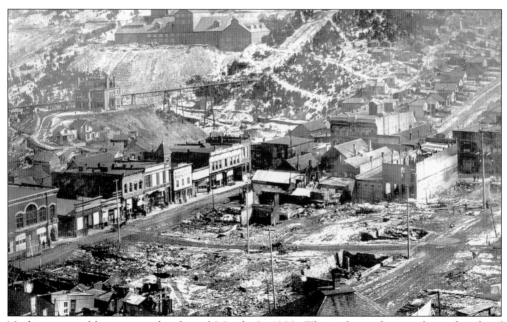

Nothing was able to stop the fire of March 8, 1900. The inferno destroyed one-fourth of Lead's businesses and threatened Homestake Mine's mills nearby. Spared were the World's Fair Restaurant, Homestake's general offices, and the old "Brick Store," or Hearst Mercantile. This photograph shows north Mill Street looking toward Bleeker Street and the Ellison shaft area. (Courtesy Homestake Veterans' Association.)

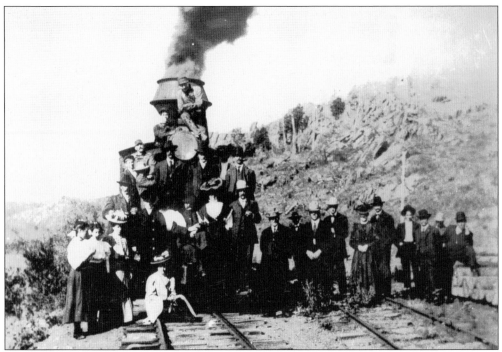

The excursion train from Nemo to Lead is seen in this photograph. This is Black Hills and Fort Pierre Engine No. 352 at Buck's Landing on October 5, 1907. The narrow-gauge hauled passengers from Piedmont on Tuesdays, Thursdays, and Saturdays. On Mondays, Wednesdays, and Fridays, it hauled wood from the Nemo lumber camp. The crew consisted of engineer Wellman, H. and Charles Lavier, and Bob Leeper. The tracks were wiped out by the 1909 flood.

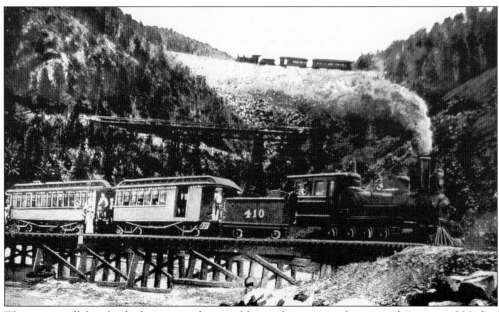

This may well be the little engine that could traveling two miles around "to gain 200 feet between Lead and Deadwood, Black Hills" says the postcard by W. B. Perkins Jr. of Lead.

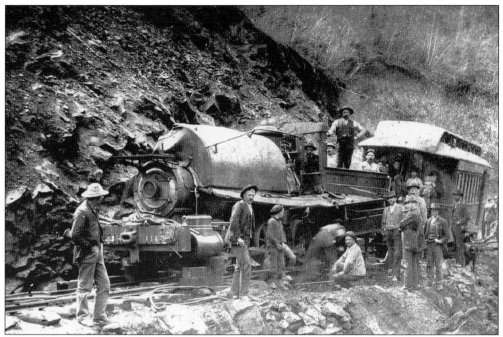

The wreck of engine No. 1 on the narrow-gauge track between Lead and Deadwood in 1890 is seen here. The cause of the wreck is not known for certain, but it appears that a rockslide or boiler malfunction might have been involved.

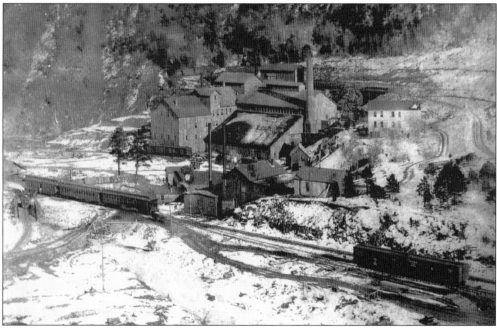

Locke and Peterson Photographers recorded this image showing "the GI and WC train and DC train at Pluma. DC turning off main line to go into Gold Run Gulch." The date is 1890, and the Kildonan Chlorination Plant is seen in the background. Lack of snow belies the fact that winter temperatures often dipped below zero.

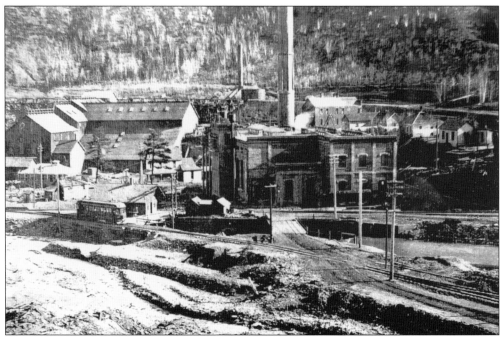

This is the Mogul Cyanide Plant at Pluma prior to 1912. Note the trolley in the foreground. The large brick building with its tall smokestack was the Belt Light and Power Company facility built in 1893. (Bloom Brothers Souvenirs photograph, Minneapolis, Minnesota.)

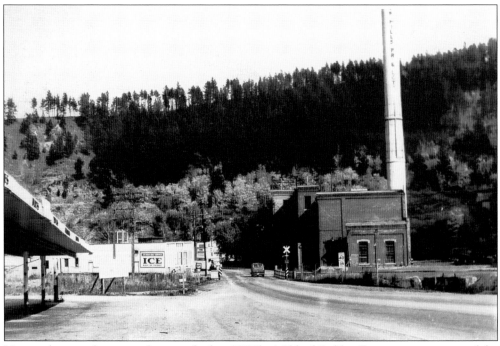

Here is the same location, photographed in 1967 by Mildred Fielder. Remaining portions of the main building were occupied by Black Hills Power and Light Company. It is now adjacent to U.S. Highway 85, a major north-south road system.

Four

THE HOMESTAKE MINE

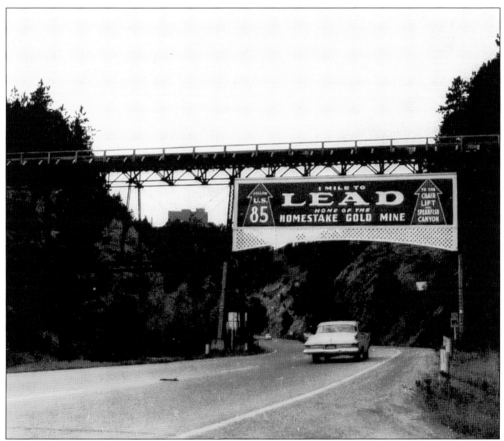

The landmark sign on U.S. Highway 85 at the east entrance to Lead is pre-1930s and is still there, though not in its original form. In the distance is the Homestake Mine, backbone of the area's economy. (Mildred Fielder photograph, 1960s.)

Moses Manuel left Portland, Oregon, when he heard of gold found by the Custer Expedition. Heading for the Black Hills, he stopped to pick up his brother, Fred, in Montana. Arriving in Custer City in December 1875, they prospected their way north. On April 9, 1876, the brothers discovered the lead of gold ore that became the fabulous Homestake Mine. The Manuels sold their claim in 1877 for $70,000.

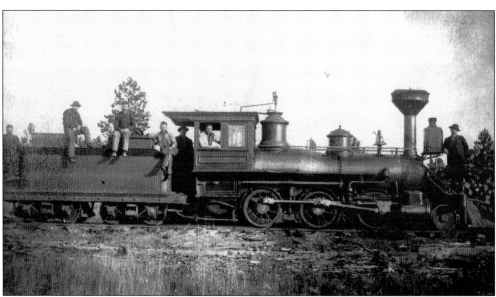

The first steam engine to "turn its wheels in the Black Hills" did so in 1881 and belonged to the Black Hills and Fort Pierre Railroad. It was named the George Hearst, in honor of one of the incorporators of the Homestake Mine. Homestake started up the railroad company to move gold ore and lumber between operations at several locations. (Courtesy Homestake Mining Company.)

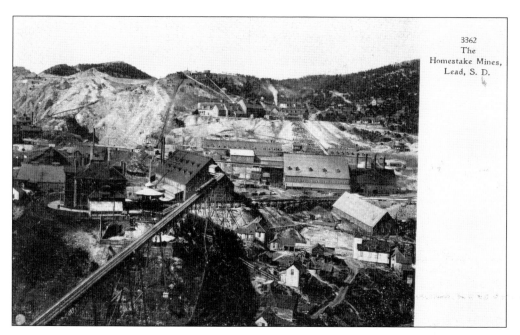

3362
The
Homestake Mines,
Lead, S. D.

An early Adolph Selige postcard shows an overall view of Homestake's extensive facilities. For 125 years, Homestake was recognized as the largest gold mine on the North American continent and the oldest continuously operated underground mine in the world. Workings reached depths of 8,000 feet below the ground's surface.

Sam McMaster, superintendent of Homestake operations from 1877 to 1884, is pictured here. McMaster applied his skills after the mining interests were acquired by a group including California senator George Hearst, Lloyd Tevin, L. D. Kellogg, and J. B. Haggin, who incorporated the mine and added another 10 acres, which included the Golden Star property.

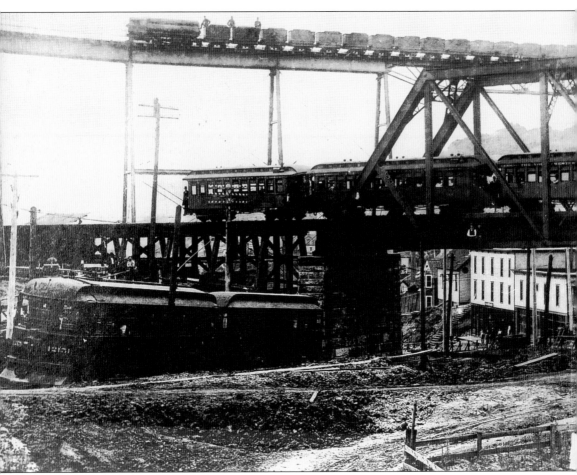

Three railroads ran through the middle of Lead in the early 20th century. Residents accepted the rumbling and the noise as part of life in a busy mining town. The upper track carries ore to and from various processing sites using the little J. B. Haggin locomotive. The center track is the line of the Black Hills and Fort Pierre Railroad (later Burlington), and the Deadwood

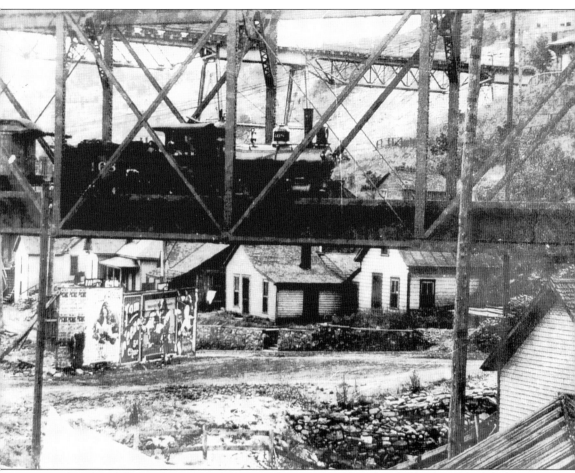

Central Railroad (later Chicago, Burlington and Quincy) trolleys shuttled back and forth below. Lead was a company town whose inhabitants were well provided for by Homestake, including free hospital and medical care, a free library, entertainment and recreation facilities, a shopping center, and a bank. Public transportation was provided to get people there.

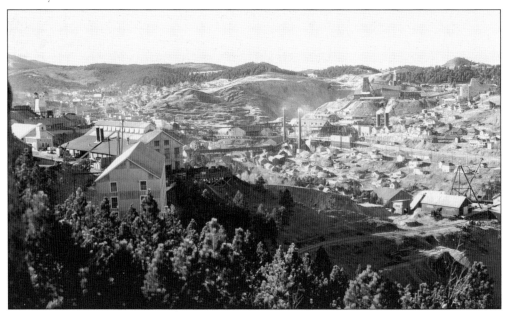

This image looks toward the Open Cut at the south end of present-day Lead. Beginning in 1918, original buildings in this vicinity were dismantled. Replacements were rebuilt on the southeastern ridge of the ever-expanding Open Cut, and by 1920, Homestake even had its own geology division. The Ross Shaft was added in 1934 and the Yates Shaft completed in 1941. Reclamation in the Terraville pit yielded 28,000 ounces of gold in the 1980s.

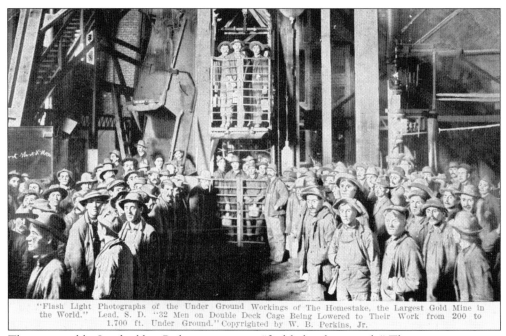

"Flash Light Photographs of the Under Ground Workings of The Homestake, the Largest Gold Mine in the World." Lead, S. D. "32 Men on Double Deck Cage Being Lowered to Their Work from 200 to 1,700 ft. Under Ground." Copyrighted by W. B. Perkins, Jr.

This postcard by Lead jobber Perkins says it is a "flashlight photograph." The caption states in part: "32 Men on Double Deck Cage Being Lowered to Their Work from 200 to 1,700 ft. Under Ground." The men are carrying their familiar metal lunch pails, no doubt filled with the staple Cornish pasties—consisting of meat, potatoes, and vegetables baked in a crust.

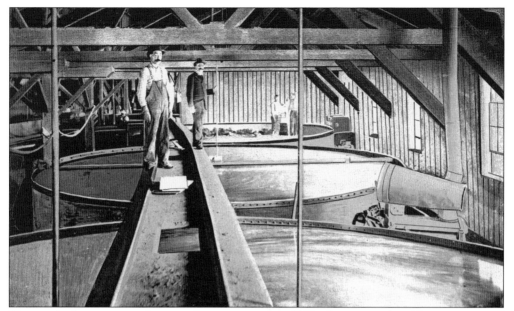

Homestake began using the cyanidation process in 1901, claiming to be able to recover 70 percent of the gold from each ton of ore milled. Partially ground ores were classified as "sand" or "fine" (slime) and treated accordingly. Refining and then assaying recovered gold are the final steps to gold bars weighing 27.42 pounds each, extracted from 2,200,000 pounds of ore per bar. (Perkins photograph.)

In 1920, Homestake began allowing the public to tour the surface facilities. Underground visits were rarely granted, but on December 4, 1927, these Lead teachers, dressed like lumberjacks, took the plunge. On one notable occasion, opera star Mary Garden and an entourage of local dignitaries celebrated at a dinner party for her down below in a cavernous underground room. (Lease photograph; courtesy Homestake Mining Company.)

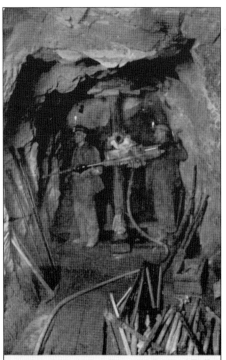

"Flash Light Photographs of the Under Ground Workings of The Homestake, the Largest Gold Mine in the World." Lead, S. D. "Compressed Air Drilling Machine in Action, Now in General Use." Copyrighted by W. B. Perkins, Jr.

Working below is hot, sweaty, cramped, and dangerous. Using compressed air was an improvement over hand-drilling but was still a backbreaking ordeal. Drill steel was fastened to pistons on the drill, which hammered steadily against the hard rock. In 1907, a fire underground made it necessary to flood the mine, which continued burning for weeks. (Perkins photograph.)

Gold may or may not be visible adhering to these rock walls and ceilings. Science dates formations in the Homestake holdings to be nearly two billion years old. They were originally composed of shales and sand deposited by seas in the Precambrian Age that were later intruded by granite. Marine fossils are still found high in Black Hills cliffs. Heat and pressure led to the formation of gold in solid rock.

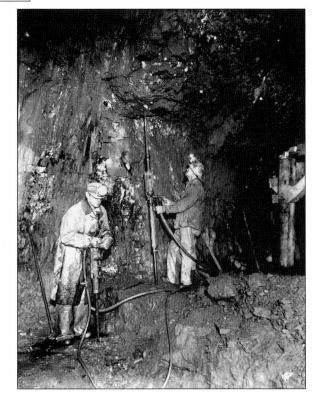

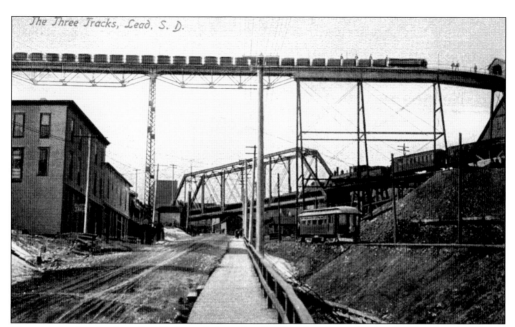

Here is another look at Lead's famed three levels of railroading. With all the mining activity occurring underground, things on the surface sometimes shifted. Sinkholes and cave-ins, as well as sliding buildings, caused local excitement over the years, including in the latter part of the 20th century. In 1965, Homestake began work on a solar neutrino observatory to trap these interesting nuclear reactions within the solar system for new energy sources.

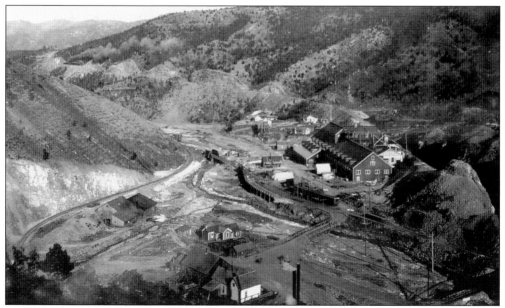

This is Homestake Plant No. 2 in Gayville in 1902. In the "Homestake Belt," four other important mining companies became part of the Homestake holdings in 1901. These were the Father DeSmet, the Deadwood Terra, the Highland, and the Caledonia, prompting further modernizations like additional power and water resources. Trains connected operations between Lead, Terraville, and other parts of the Northern Hills.

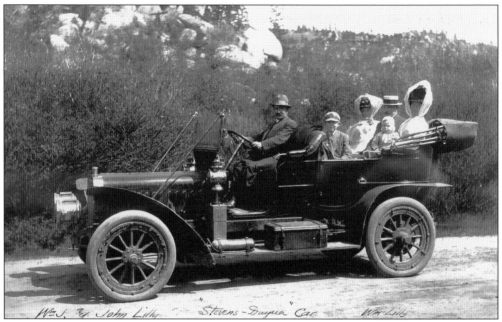

William J. Lilly was the master mechanic for Homestake during its early years. He moved to Butte, Montana, in 1904. In June 1911, Lilly is seen driving his family in a Stevens-Duryea tourer car, manufactured in Chicopee Falls, Massachusetts. When introduced, it was the first car with a one-piece windshield.

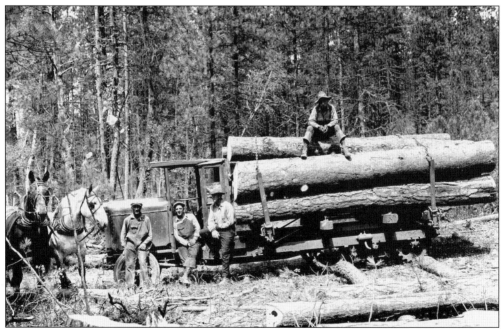

Workers take a break while harvesting lumber for Homestake in the early 1920s. Note the cogged and chain-wheel track drive of the Linn truck under a load of Black Hills pine. The vehicle could travel at 10 miles per hour empty and 1 to 2 miles per hour loaded. Happy Larson and Albin Erickson are the drivers. The horses skidded the logs to the loading site.

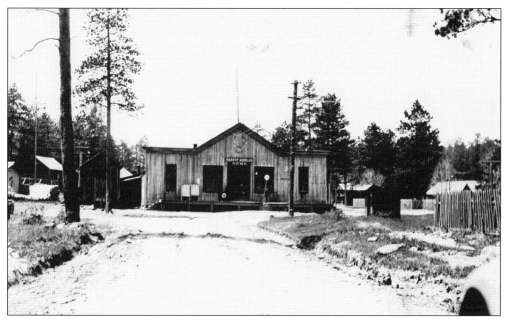

The sign over the door reads "Hearst Mercantile Company - Nemo." Nemo is "omen" spelled backwards and was thought to be a lucky gesture for continued prosperity. The little store building is still in use today as part of the Nemo Guest Ranch.

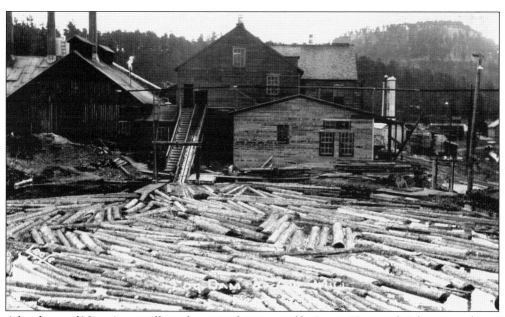

A log dam and Nemo's sawmill are shown in this postcard by Lease. Homestake's logging industry was nearly as large as its mining operations. The first public sale from our national forests was made to Homestake in the late 19th century. In later years, pulpwood and poles made up three-fourths of its commercial product—the balance being saw timber.

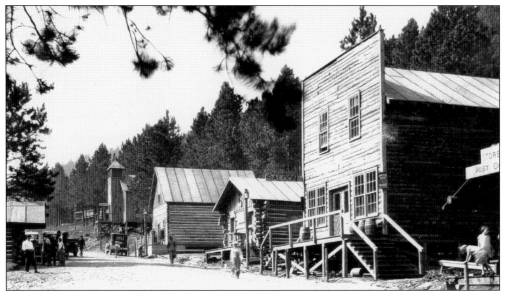

Homestake celebrated its first 50 years with a Golden Jubilee extravaganza on August 6 and 7, 1926. An old mining camp set was constructed in Poorman Gulch at the head of Deadwood Gulch for the event. A pageant, band concerts, parades and other historical events marked the occasion with hundreds of participants and thousands of spectators. Some early area mines were the Nutless, Little Lulu, and Hoodlebug. (Courtesy Homestake Mining Company.)

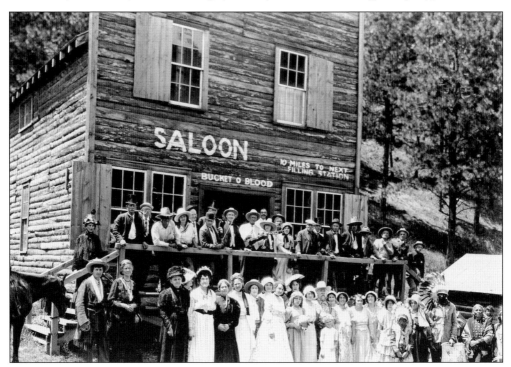

The Bucket O' Blood saloon serves as a backdrop for the cast of characters participating in Homestake's Golden Jubilee. Several of the ladies' dresses and gents' wardrobes appear to be authentic and from about the 1880s.

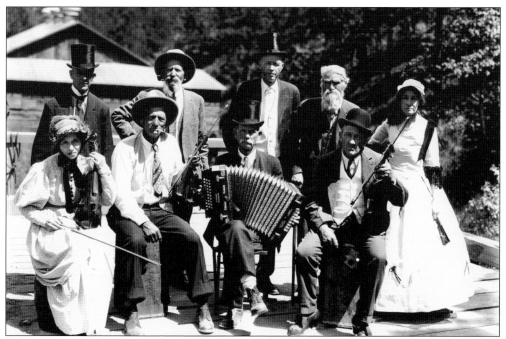

Seen here are merry music makers for the Homestake anniversary. "Grab yore partners and swing 'em high" was a theme for festivities in a roaring gold camp. The fellow with the concertina (front row) sports a top hat and tie, contrasted with work shoes and socks below.

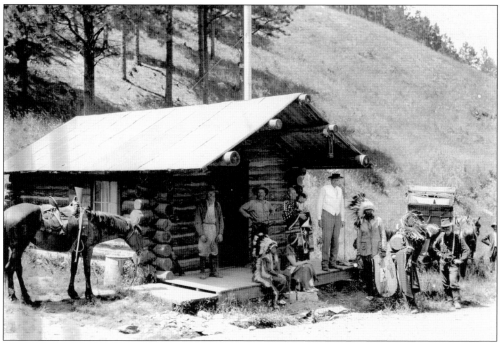

A re-created miner's cabin sits next to the saloon in Poorman Gulch during the Golden Jubilee. These characters appear ready for the action to start, perhaps a parade. Glendale Drive and Dumire's Motor Lodge occupied the location in the 1950s.

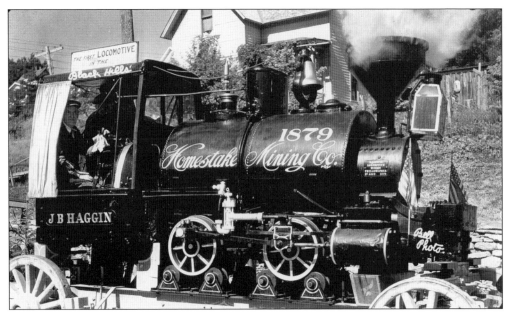

The first locomotive of any type in the Black Hills was the J. B. Haggin, namesake of James Haggin, a partner in the Homestake company. The engine was manufactured by the Baldwin Locomotive Works of Philadelphia and was used to propel ore cars along the mine's elevated tracks. The Haggin appeared in parades and gave rides before being retired to Deadwood's Adams Museum.

Charles Windolph was a former sergeant in the U.S. 7th Cavalry under George Armstrong Custer. Sergeant Windolph survived the Battle of the Little Big Horn and earned a Medal of Honor for bravery there under Maj. Marcus Reno's command. Sergeant Windolph and fellow trooper Dan Newell both worked for many years for Homestake following their military service. Newell also received a Medal of Honor. Sergeant Windolph lived to be nearly 100.

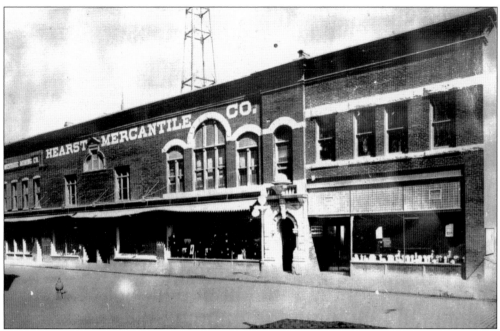

Hearst Mercantile was the company store for mine employees and their families. Known as the Brick Store, it was the forerunner of today's superstore. Nearly anything could be bought or ordered, and credit could be arranged. Several generations of Lead residents shopped here almost exclusively for their household needs. (Courtesy Homestake Mining Company.)

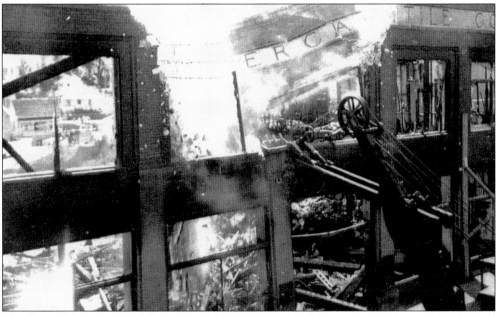

The Hearst Mercantile building in this photograph replaced the earlier version and was located up the street from its original site in 1931. On August 31, 1942, and during the hard times of World War II, it burned to the ground. Gold mining was temporarily halted by the government during the war and resumed July 1945. (Courtesy Homestake Mining Company.)

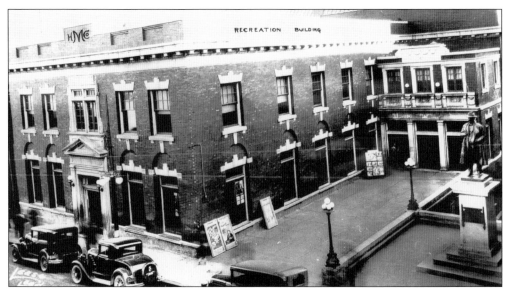

Among Homestake employee amenities was the recreation building, which housed club rooms, a swimming pool, the Phoebe Hearst Free Library, a billiard hall, bowling alley, gymnasium, and the famed Opera House that could seat 1,000 people. To the right is a statue of T. J. Grier, superintendent of the Homestake Mine for three decades. (Lease photograph, 1920s; courtesy Homestake Veterans' Association.)

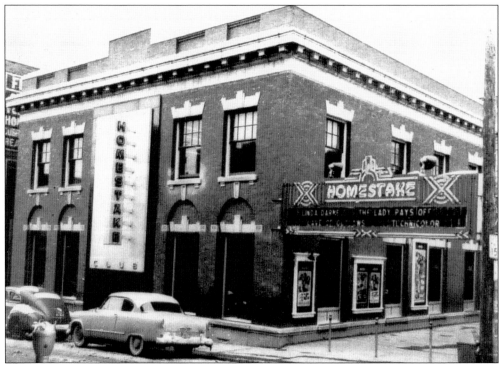

The Homestake Club, photographed here in 1950, shows some adaptations to the original building. In the 1980s, the Opera House was gutted by fire and, as a city landmark, has been undergoing complete historic restoration. (Courtesy Homestake Mining Company.)

Five

DEADWOOD'S LATER YEARS

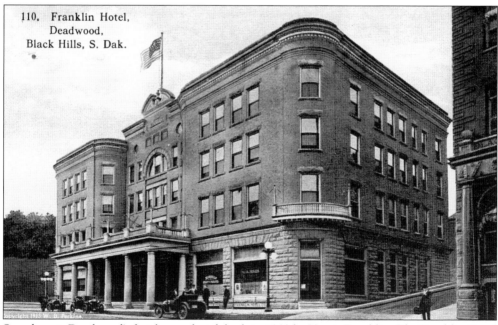

Seen here is Deadwood's first luxury hotel, built in 1903 by Harris Franklin. The Franklin Hotel is still a popular spot. Its large veranda features a number of rocking chairs for the relaxation and comfort of guests. The four-story brick building boasted 80 rooms (half of them with baths) and elevators. An addition followed sometime in the 1920s. The Deadwood Business Club raised $150,000 to guarantee financing so the hotel could be built. (Perkins photograph.)

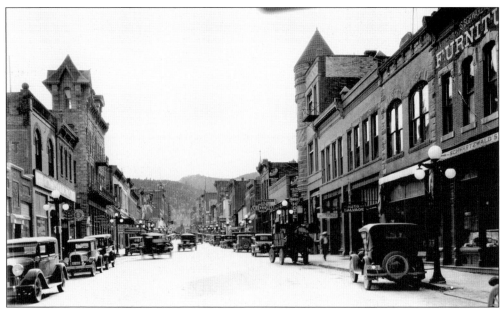

Photographed here is Main Street in the 1920s. The Fairmont Hotel (with the turret) is seen on the right, as is the Chevrolet agency, a Goodyear tire distributorship, and an auto salvage business. At left is Ruth Brothers, George V. Ayres Hardware, a secondhand store, and the Zoellner and Haines buildings. The Fairmont touted a marble swimming pool in its basement. Deadwood's busy streets were paved with brick in 1907 at a cost of $75,000. They exist today.

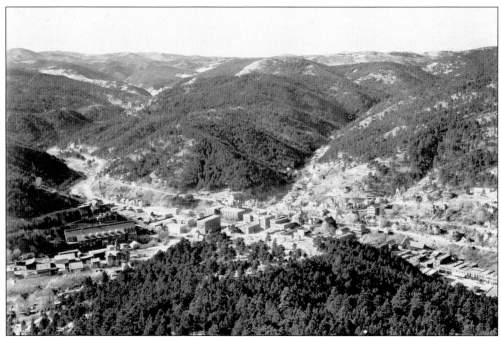

Deadwood's terraced levels are clearly visible from the vicinity of Mount Moriah Cemetery. This area comprised several small mining camps that were incorporated into Deadwood proper in 1881, when the first school district was formed. The town's early boundaries resembled a Y shape.

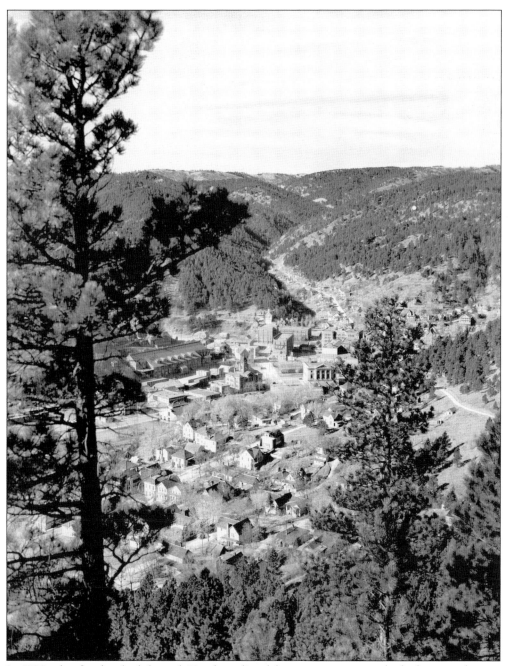

In 1883, a big flood rushed through Deadwood's gulches, removing not only the business district, but also much of the accumulated congestion as well. The result was a neater and cleaner emerging city with some planned growth. Al Burnham was an architect who arrived with the gold rush but who stayed to design and build many of Deadwood's prominent permanent buildings, now designated national historic landmarks.

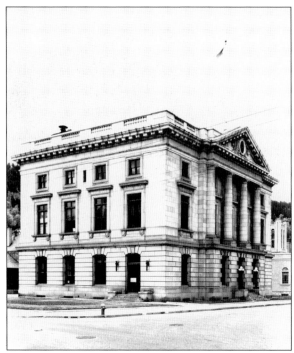

Deadwood's U.S. post office and federal courts building—built 1904 to 1907—is a classic example of the American criteria for public buildings. It is a separate entity on its site, has a symmetrical shape with more than one public side and entrance, and carries ornate embellishment. Over the years, Deadwood's federal court tried many important and historical cases.

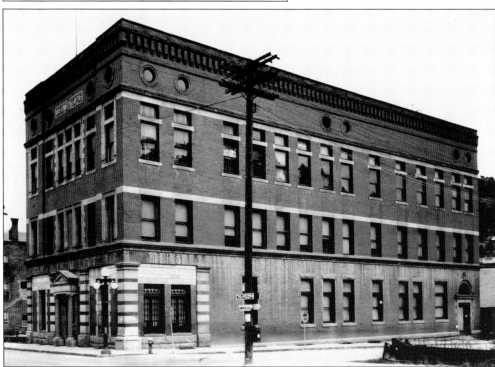

From the earliest days, Masonic orders and secret societies played a large role in the social fabric of Black Hills communities, and Deadwood was no exception. This impressive brick building is Deadwood's Masonic temple located at the west end of the main business district. It is still in use today.

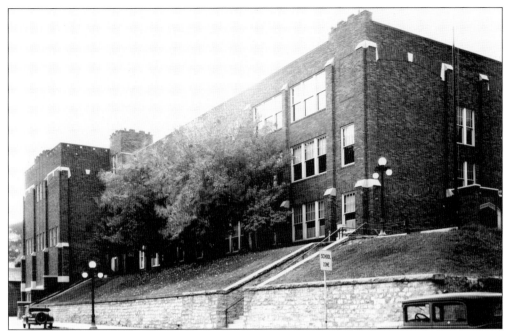

Deadwood's brick high school building occupies a grassy knoll at the upper west end of town. The first public school was a two-story wooden structure at Pine and Water Streets, built in 1877. The first school district contained four wards. At the top of the stairs, at right, sits a large urn that appears identical to the one on the grave of Calamity Jane.

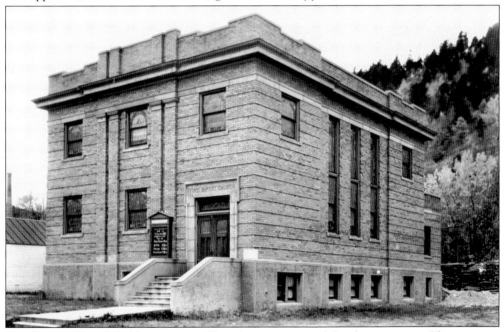

First Baptist Church held services on Thursday evenings and Sunday mornings. The entrance sign says: "Dan J. Rueb, Pastor, Phone 162." Pastor Rueb's message was "To talk with God, no breath is lost." Sunday school preceded the regular services at 11:00 a.m. Though the cornerstone is dated 1888, the building appears to have been updated.

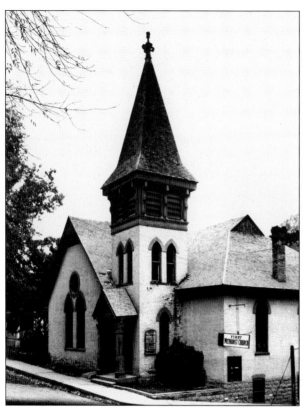

Rev. R. H. Dolliver preached some feisty sermons at First Methodist Church and was asked by the press to tone it down a little when he railed publicly against "the gods of Deadwood —King Faro, Stud Poker, Bacchus and Gambrinus," which they felt was bad for business. Reverend Clough later welcomed those from all walks of life by refusing to "draw the line where God has not."

I had a bang up time

While Deadwood was definitely showing signs of taming down, its legend lived on. This postcard sent June 22, 1911, to a "Mis Jemima Roth" in Sturgis said, "helo kid. . . . how (are) the high heal boots treating you(s)."

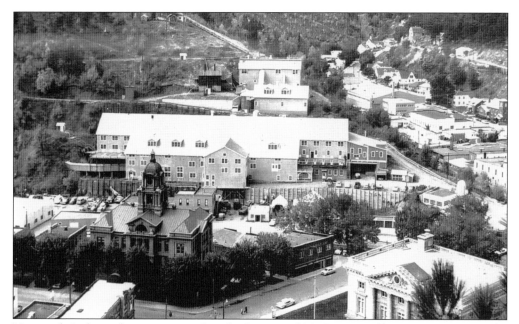

Homestake's slime plant was erected at the bottom of McGovern Hill in 1906 to remove the finest particles of gold from pulverized ore, one of many steps needed to obtain a final product by separating grains from a slurrylike limestone. The slime plant operated until 1973 when it was replaced by newer methods. In the center foreground is the Lawrence County Courthouse, flanked by the U.S. post office and federal courts building at right.

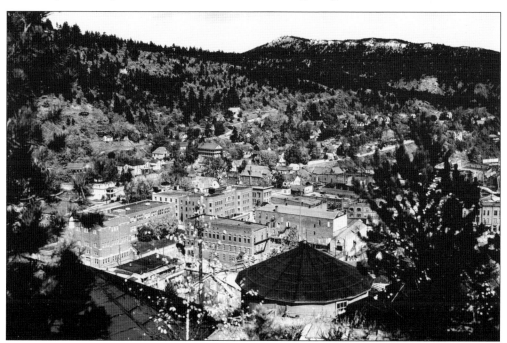

Looking northeast from McGovern Hill, prominent in the center are the high school, Masonic temple, Franklin Hotel, and the Deadwood Theater, photographed in the late 1920s or early 1930s by Bert Bell. Beyond the ridge and about 12 miles distant is the college town of Spearfish.

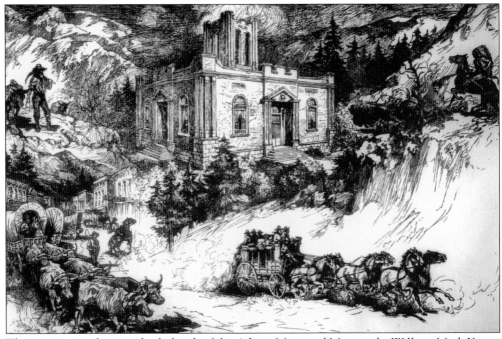

This romanticized pen-and-ink sketch of the Adams Memorial Museum by William Mark Young is dated 1930. It portrays the elements of Deadwood's colorful past that are interpreted inside.

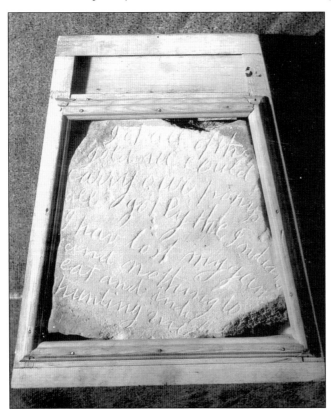

Real or hoax? Clues confirming gold hunters were in the community long before the rush to the new Eldorado included the Thoen Stone, shown here. Louis Thoen, a stonecutter, claimed to have found the sandstone slab in 1887, left behind by prospector Ezra Kind in 1834, who scrawled, "All ded [sic] but me Ezra Kind. . . . I have lost my gun and nothing to eat and Indians hunting me."

The Adams House in the presidential district of Deadwood is a Queen Anne jewel from the 1890s. Built by grocer W. E. Adams, the mansion had a sad legacy through several family tragedies. The home was acquired by the City of Deadwood after Adams's death. Things were just as they were left when the second Mrs. Adams turned the key and walked away. In 2000, the restored Adams House opened to the public.

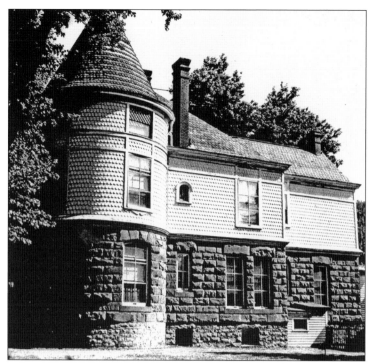

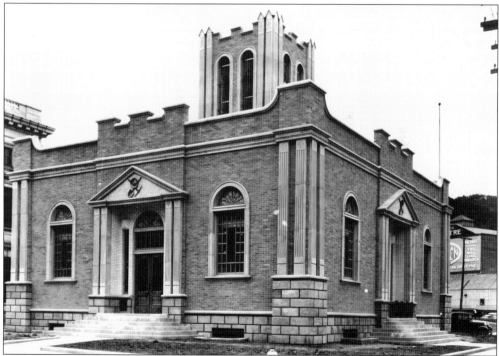

The Adams Museum, designed by Deadwood mayor, architect, and engineer, Ray L. Ewing, was founded in 1930 by W. E. Adams in memory of his first family. The unique exterior is a mix of art deco and neoclassic influences, though the pick, shovel, and miner's gold pan over each doorway reflect the museum's true theme. The tower has carillon chimes.

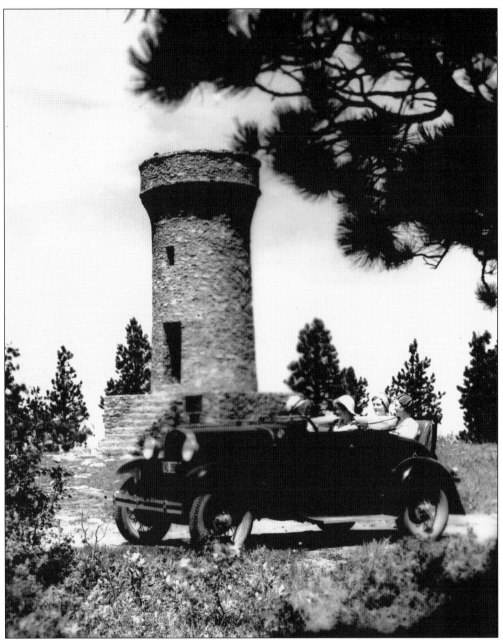

Built of native stone, the Theodore Roosevelt Memorial on Sheep Mountain—renamed Mount Roosevelt—was the first American monument to honor the late president. Seth Bullock, "upon Teddy Roosevelt's death in January 1919 . . . took immediate steps to have the Black Hills Society of Pioneers establish a memorial," said a local newspaper. It was dedicated by Maj. Gen. Leonard Wood in September 1919, shortly before Bullock's own death in that same month from cancer. Bullock requested to be buried high on Mount Moriah so that he could be in view of his good friend's place of honor.

Pres. Theodore Roosevelt did not spend much time in the immediate area, but he did meet U.S. marshal Seth Bullock on the Dakota plains, where Bullock initially mistook him for the fugitive he was hunting. It was the start of a lifelong friendship build on mutual respect. Bullock even brought a trainload of cowboys and horses to Washington, D. C., for Roosevelt's inaugural parade. (National Archives photograph.)

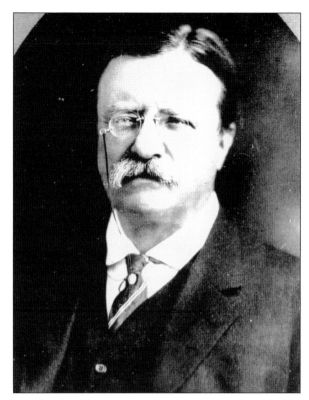

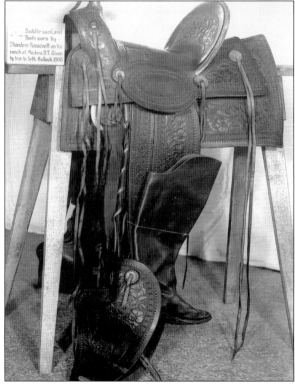

This fine hand-tooled saddle with loop seat, square skirts, and tapaderos was a gift from President Roosevelt to Seth Bullock, as were the high-top boots shown here, in 1908. Roosevelt used these items at his Maltese Cross ranch located near Medora in present-day North Dakota's Badlands.

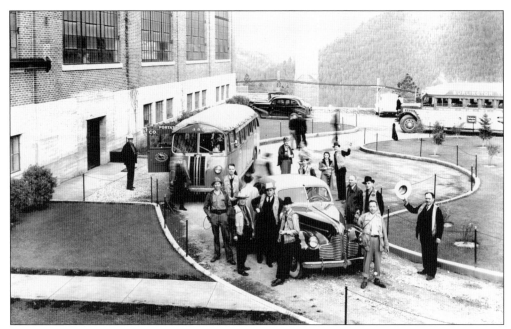

Black Hills tourism was in fine shape prior to World War II. In 1940, a nationwide delegation of Automobile Association of America (AAA) members made a stop at Homestake Mine and Deadwood. The men in the foreground are from the West Coast. The buses are from Black Hills Transportation Company and Burlington Trailways.

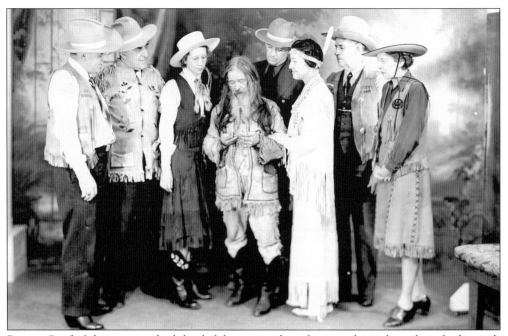

Potato Creek Johnny wore high-heeled boots in this photograph, making him look much taller than his less-than-five-feet stature. Presenting the gold watch are, from left to right, Jay Barber, unidentified, Nell Perrigoue, Johnny Perrett, unidentified, Bea ?, F. W. Pouder, and "Sprit" Johnston.

Bert Bell came to Rapid City in 1927 as a photographer for Chicago and Northwestern Railroad. An avid promoter, Bell soon saw great potential in area tourism. He photographed the beginning construction of Mount Rushmore, headed Deadwood's chamber of commerce, and traveled extensively promoting international Highway 85 from Canada to Mexico. It didn't hurt that the route ran through the middle of Deadwood.

This is what Deadwood hospitality looked like over half a century ago. Deadwood had a winning combination of authentic history and Wild West entertainment, providing great fun for vacationers of all ages.

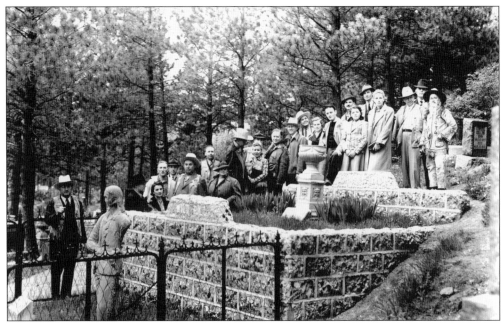

The graves of Wild Bill Hickok and Calamity Jane lie high above Deadwood on Mount Moriah. Hickok's statue is missing its left arm, right hand, and parts of the facial features. By 1955, it could no longer stand on its own and was removed. Potato Creek Johnny stands near the spot where he would be planted three years later, but he probably did not know it at the time.

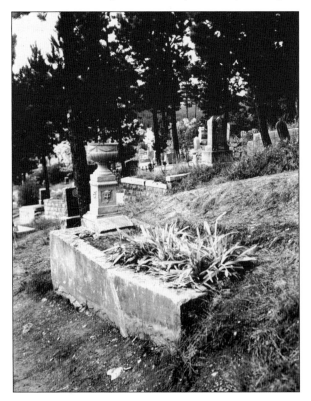

Calamity Jane's final resting place in the 1920s is forlorn and unattended. By the time the photograph above was taken in 1940, landscaping and beautification of the sites had taken place, and the ugly erosion seen here was filled in. On the urn, the laughing face of Lucifer is seen. Or is it Bacchus? Jane had a Christian burial and the largest funeral ever held in Deadwood, with over 10,000 people attending, said news reports of the day.

The Bullock Hotel—later George V. Ayres Hardware and again the Bullock Hotel—still stand proudly today. Ayres pioneered the building of many roads in the area with one of the best mountain road systems in the West by 1912. In the rooms above, Seth Bullock's ghost is said to walk the halls. Restored, the hotel and ghost remain popular with guests.

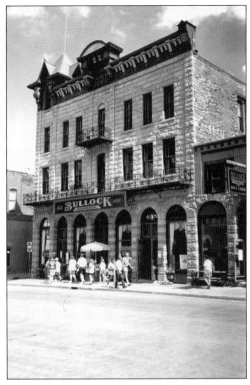

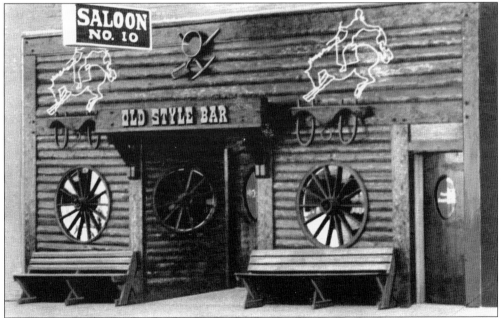

Another Deadwood landmark, the Bodega, built in 1891, was long a favorite place for eating and libation. Its 19th-century furnishings included a mahogany and brass back bar and its signature black-and-white tile floor. This is the "new" Old Style Saloon No. 10, located across the street. Called the "only museum in the world with a bar," reenactments of Wild Bill's shooting are still held here.

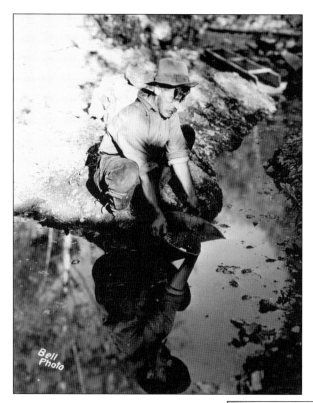

Potato Creek Johnny Perrett is panning for gold as a younger man and without his familiar gray beard. He found the largest gold nugget ever taken from Black Hills streams in Potato Creek near his cabin. Weighing seven and three-fourths ounces, he sold it to W. E. Adams for $250. Prospecting did not provide a stable home life, however. Johnny's wife left him shortly after she could only provide lettuce as a meal for guests.

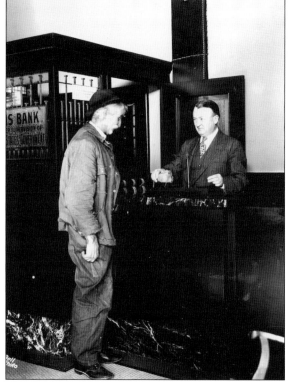

For the tourist's camera? This modern-day prospector is having his pouch's contents weighed on a gold scale, something the banker does not seem too familiar with. Signs on the teller's cage reveal that the bank is a member of Deadwood Business Club and a 1929 booster of the Custer Battlefield Highway Association. The large sign says that the bank is "under supervision of United States Government."

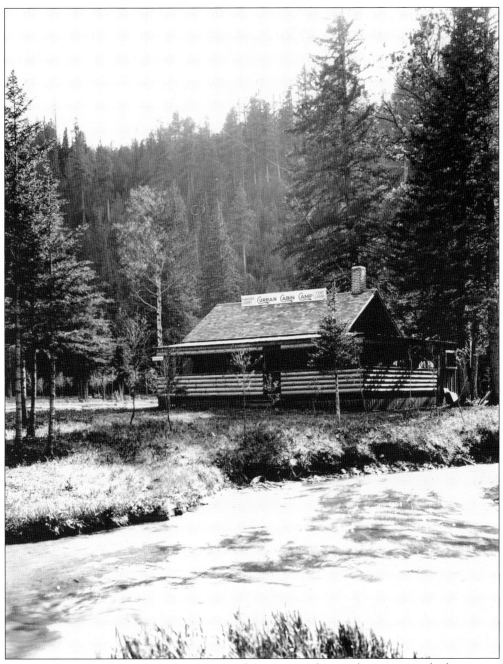

What is more refreshing than a vacation in the pines? A clear, rushing stream, shady summer days, and cool nights in crisp air brings another kind of wealth to be discovered in the northern Black Hills. Gold is still here, waiting to be found amid peaceful surroundings. Curran's Cabin Camp was one of several rustic getaways popular over the years.

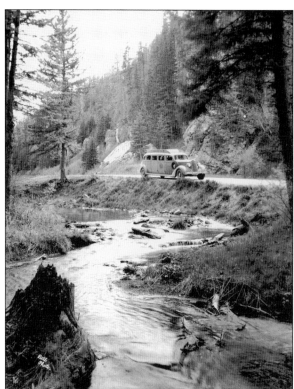

Leisurely traveling through one of the lovely canyons around Deadwood can make the day pass quickly. In gold rush days, the tiny waterfalls seen in this stream would probably prompt prospectors to try their luck by looking for trapped flakes of gold in the sands below.

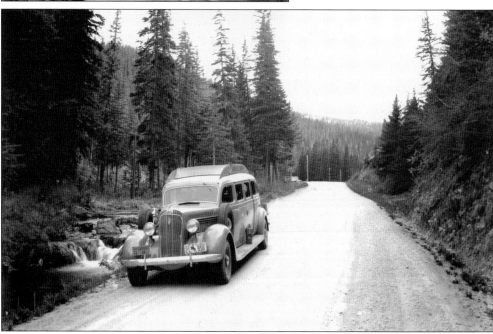

This Wyoming tour bus halts on a graded canyon "super road." The license plate says 1936 and features the state's famed bucking horse logo. Just in case, there are two spare tires that appear extra sturdy, and a second can of gas can be seen on the running board. There was no emergency road service back then.

Northern Black Hills scenery is spectacular, but miners did not care about the beauty of the region, for their quest lay below the surface of the earth and under its waters. Many pristine hidden spots like this one did survive untrampled, however.

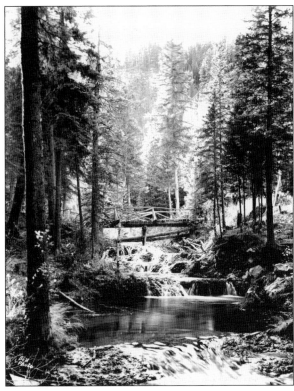

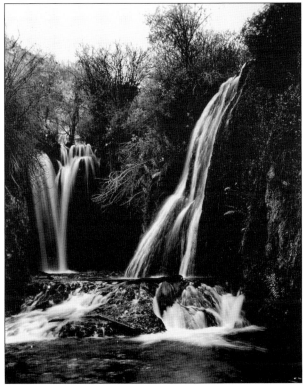

Roughlock Falls got its name from the surrounding rugged terrain. Wagons passing through had to "rough-lock" their wheels when descending steep and dangerous places. The location is west of Deadwood in Spearfish Canyon at Savoy Crossing. The winter scene finale to the 1990 movie *Dances With Wolves* was filmed a short distance away.

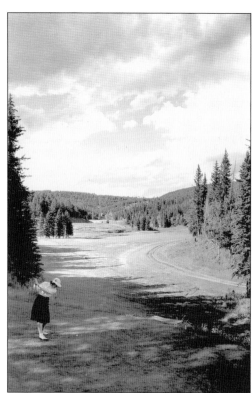

Stagecoaches used to run where progress has taken over. Golfers in the 1930s played on some fine courses not far from Deadwood in several directions.

S. "Sam" Goodale Price, "rockologist," historian, and author is pictured at his home in Spearfish Canyon, tumbling some of his finds. Price and his wife made native rocks and minerals into jewelry and novelty souvenir items from the Black Hills. He wrote many authoritative articles and books about Deadwood's past. (Mildred Fielder photograph, August 23, 1963.)

George Redfern is photographed with a grandchild in September 1957. He was employed as an engineer on the Chicago, Burlington and Quincy route out of Deadwood on June 10, 1893, and retired 54 years later in 1947. Redfern siding is named for him.

The last Mallett engine, No. 4108, is leaving Deadwood on Burlington tracks for a weed-spraying trip. This photograph was taken on July 18, 1951. The wonderful, smoke-belching locomotives were on their way to extinction during this era, leaving only nostalgia and the sound of a fading whistle behind.

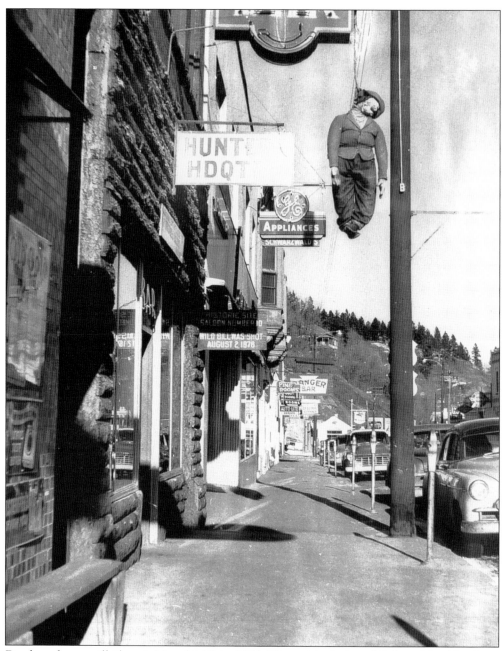

Deadwood was still "hangin' 'em high" in 1957. The original site of Saloon No. 10, where Wild Bill Hickok was killed, is shown on the left in the lower town district. It was also known in 1876 as Nuttal and Mann's Saloon. The Ranger Bar and rental rooms can be found farther down Main Street, and, yes, that is a house perched precariously on the hill beyond. (Mildred Fielder photograph.)

Six

GOLDEN GULCHES

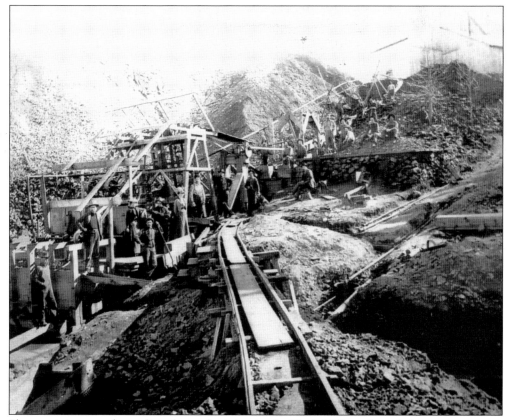

Placer mining was the earliest form of mining in the Black Hills and needed a constant water source to extract the precious gold from its host material. This elaborate operation is part of the Iron Hill Mine properties near Carbonate in 1886.

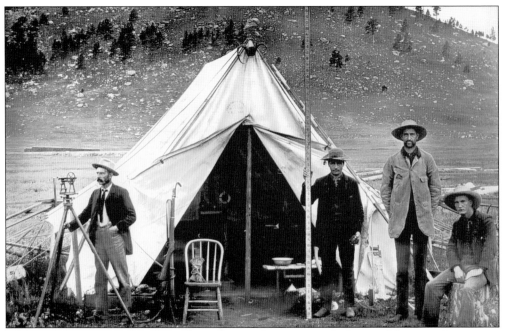

This surveying crew is getting ready to change the countryside forever. The exact location is uncertain but may be in the Bear Butte or Whitewood districts. The tall man may be Bill Linn, a former shotgun messenger-turned-freighter and the only man in the Hills at that time who was nearly seven feet tall. He may have brought supplies to the camp. (W. J. Collins photograph.)

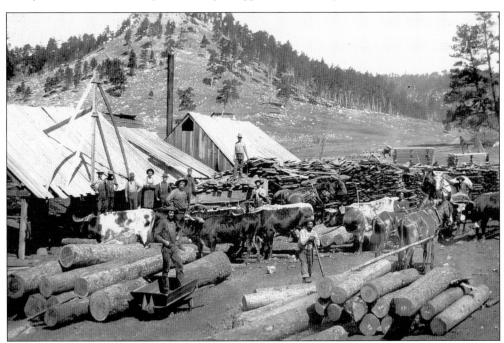

The sawmill appears to be in the same vicinity as the photograph above. Note the bull train in the middle of the activity. The large piles of slabs were probably used for shingles, fences, and other forms of "rapid construction." (W. J. Collins photograph.)

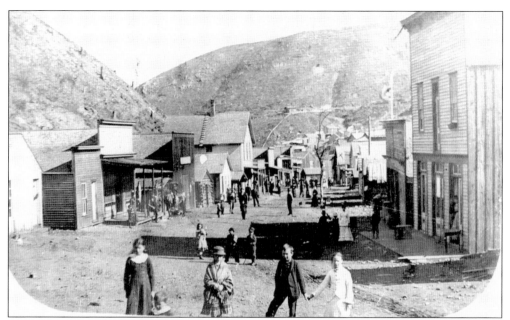

Golden Gate, Dakota Territory, is pictured here in 1879. Located at the upper end of Central City, many small hamlets like this one were also eventually absorbed into large communities. In the fall of 1876, Golden Gate had 12 to 15 homes, four arrastras, the Golden Gate and Father DeSmet Mines, and the Erin Mill. At the time of this photograph, the Homestake and DeSmet Mines were engaged in a water dispute. (Courtesy Homestake Mining Company.)

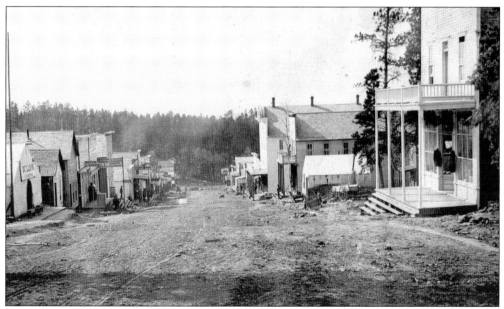

Carbonate Camp, 10 miles west of Deadwood, sat high above other mining camps and held a lofty position of prestige due to the presence of the Iron Hill Mine that was especially rich in silver ore. A silver mill and smelter soon were in operation as Carbonate prospered. Pictured left is the Bullion (tent), Stock Exchange, and Mattson-Johnson groceries. At right is the Huggeman Hotel, built in 1889.

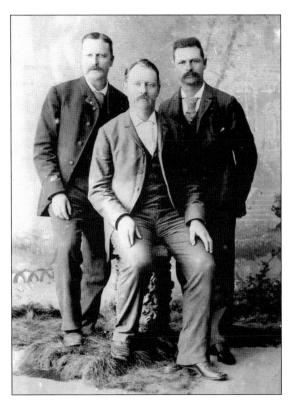

Charles "Raspberry" Brown (center) and companions are photographed in New York City. Brown, a lifelong bachelor, was well known in the Black Hills for growing fine raspberries and other produce, which he sold in gold camps around Deadwood and Carbonate, where he made his home. This photograph was taken in 1892, when he received a sizable inheritance and traveled to his home in the state of New York to collect it.

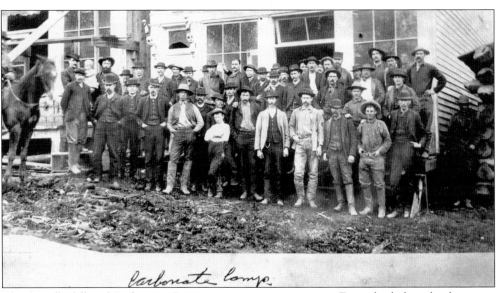

The friendly folks of Carbonate Camp are waiting to greet you. Even the lad in the front row seems defiant. Where are the womenfolk? Twin barber poles visible on the building behind the group probably indicated the proprietor did a good business in mustache trimming.

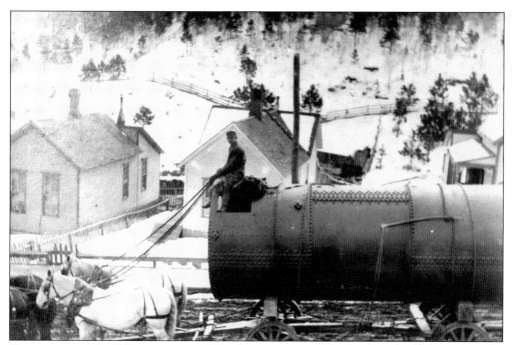

Getting around the Hills in winter could be daunting in itself, but hauling this boiler up winding roads to Carbonate in the 1880s required a 10-horse team and a driver with a sense of adventure; his perch is rooftop high, with nothing much to hold on to.

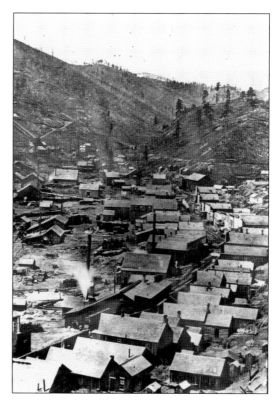

Central City, Dakota Territory, is seen in 1878. Rapid growth of mining communities was a fire insurance company's worst nightmare. And how does one know where his property lines are? Before 1900, there were three separate mining unions in the Black Hills. Central City had one, as did Lead and Terry.

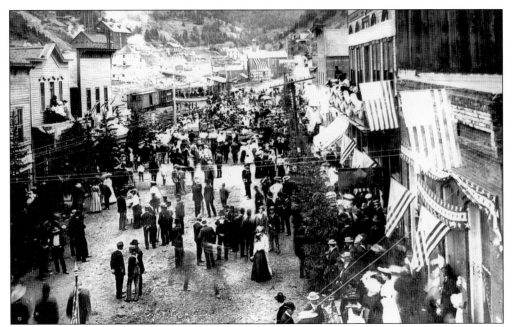

This July 4, 1890, photograph in Central City shows crowds gathering on streets, balconies, and rooftops while judges in the grandstand get ready for the competitive events. Horse racing, foot races, and hose cart races were very popular pastimes. The Father DeSmet Mine and Mill can be seen at the upper left.

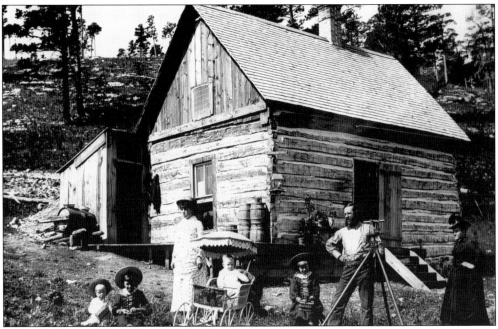

A prosperous Black Hills surveyor and his family pose in this photograph, probably in the late 1870s or early 1880s. Note the "Little Lord Fauntleroy" clothing on the children and the fancy wicker carriage that are obviously expensive. The home appears crude in comparison on the outside but is no doubt comfortable in furnishings. (W. J. Collins photograph.)

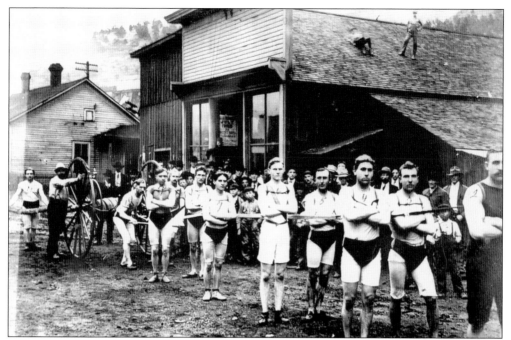

The Central City, Golden Gate, and Terraville (CG&T) hose cart crew line up for serious business in front of wide-eyed youngsters and some roof dwellers. The rules were to run or race 300 yards, couple to a hydrant, and then lay 300 feet of hose in the fastest time. Rivalries and loyalties frequently made the outcomes exciting. A round of fisticuffs afterward was expected and enjoyed by all.

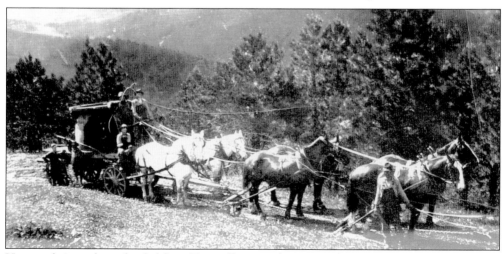

Homestake's crusher is hauled from Terraville to Lead in 1924. The scenery was great, but the air is a little thin a mile high in the Black Hills. No doubt the men considered it all in a day's work. (Lease Photograph Finishing Service, Lead photograph.)

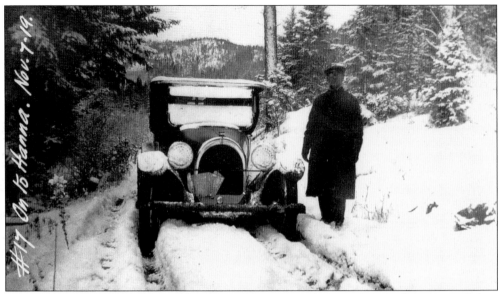

"On to Hanna" says this postcard dated November 7, 1919, but it appears to be easier said than done. The windshield is frosted over, and the car is high-centered in its tracks. Heavy, wet snows are common to the Black Hills at elevations often a mile high or more in some areas.

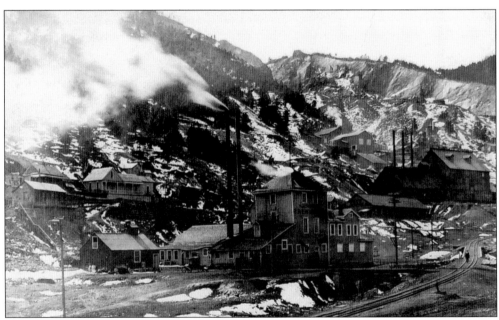

Central City's Black Hills Brewing Company was a large operation, as can be seen in this photograph taken around 1900. Wide- and narrow-gauge tracks run past the entrance to the plant, ensuring that bottled beverage products could be on their way to thirsty customers in the fastest possible time. It was sold to the Minneapolis Brewing Company in 1902. Father DeSmet Mill is in the background.

This artistic *c.* 1900 poster for German-style "bock" beer is from the glory days of Central City's Black Hills Brewery. Such a colorful advertising piece would be quite a collector's find today.

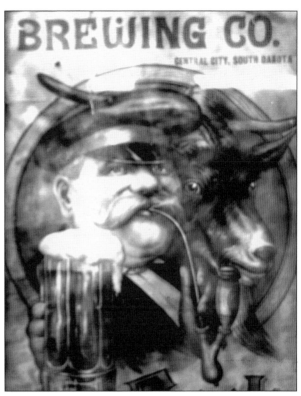

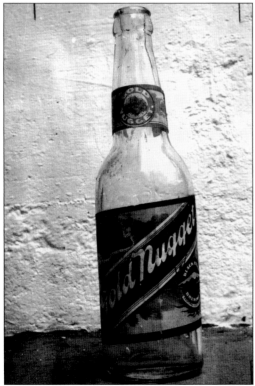

The pride of the northern Hills was the crisp, amber Gold Nugget label beer produced by Black Hills Brewing Company. Since water was a scarce commodity in mining communities and often contaminated by industrial wastes, it seemed only logical to make beer the substitute beverage of choice.

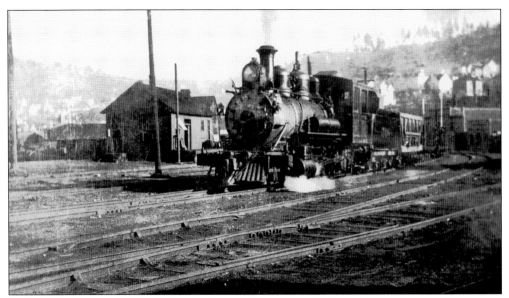

Ruby Basin ore train No. 538 is shown leaving Deadwood sometime before 1914. James Conzette of Galena was president of the Ruby M&M Corporation for four terms. Conzette lived in a modest log cabin nestled amid the saloons along Galena's main street but wielded considerable influence in the mining industry for some time.

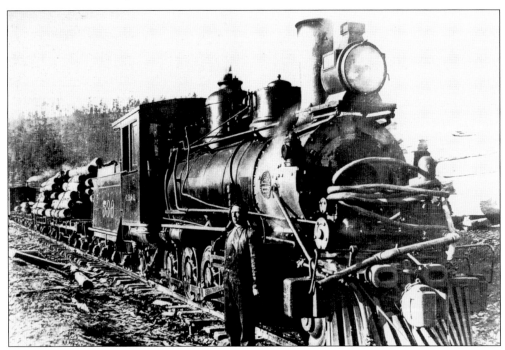

Here is engine No. 538 of the Chicago, Burlington, and Quincy at Merritt in 1911. Fireman Bob Leeper is standing in front of the narrow-gauge workhorse. This train had a coupler that also allowed it to accommodate standard-gauge equipment, and the hose on the front of the locomotive was an innovative idea that enabled the crew to take on water from nearby creeks in case of emergency.

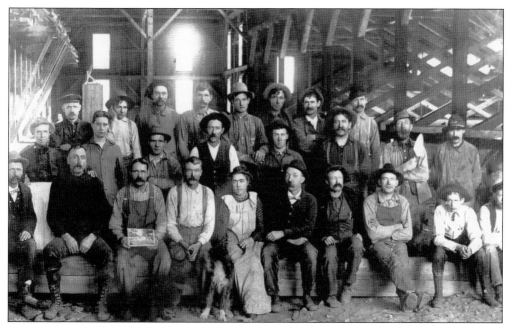

The crew of the new Branch Mint Mine near Galena pose for a photograph at the time the buildings were being constructed. The Branch Mint caused much interest in the region but never fulfilled the dreams of its several owners.

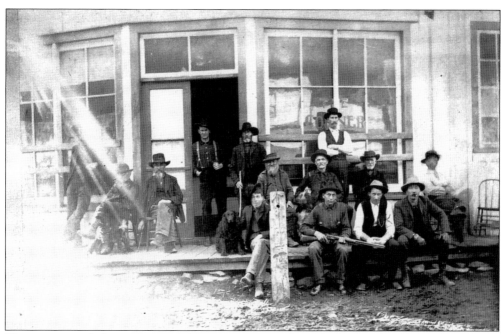

The gang is at Galena's Corner Saloon in 1904. Listed on the back of the photograph are Pat McDermott (with hat), two unidentified men, Prudence Moran (with dog), Jim Bryan, Sammy Moll, Ear Kopp, Alfred Dorey (with gun), Herbert Groshong, Joe Bailey (back of Groshong), Mr. Kotzebeau (with cigar), Pop Coyle (back of Dorey), and Fred Borsch Sr. (far right). Kotzebeau is an interesting fellow who seems to pop up in many diverse group photographs.

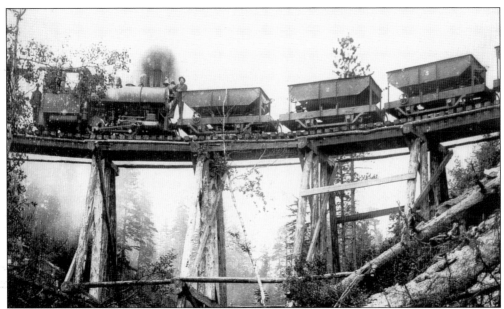

Pushing ore cars over a high trestle in 1906 is the little engine Natalie of the Branch Mint Line—a spur connecting to the Chicago, Burlington, and Quincy from the Hoodoo Mine to the Branch Mint Mill via Terrible Gulch. Later owners sold Natalie to Montana's Wonder Park Museum in 1953. She then went to California and has since returned to South Dakota as an attraction at Crazy Horse Memorial in the Southern Black Hills. (Courtesy Chet Borsch.)

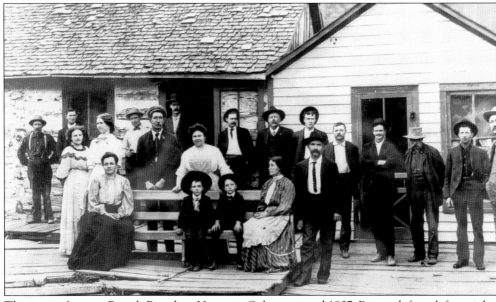

This image features Borsch Boarding House in Galena around 1907. Pictured, from left to right, are the following: (first row) Mrs. Burbank, Fred Borsch, Chester Borsch, and Ella Borsch, and Fred Borsch Sr.; (second row) an unidentified teamster, an unidentified doctor, Pearl Smith, Verda Scroggins, Clint Hoselton (bow tie), Hans ?, ? Smallwood, Anna Hunter (cook), ? Butler, Ike Trotter, Ralph Hoskins, Fritz Delman, ? Spitler, Fred Hart, Little Jack Hall, and Big Scott ?. (Courtesy Chet Borsch.)

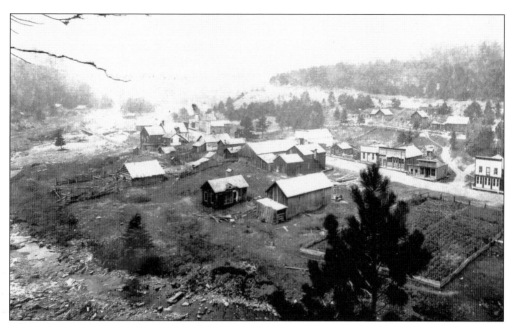

This bird's-eye view shows Galena in 1910. The little building in the center is the post office. Facing structures are Jim Conzette's log cabin, Irish World Saloon, and Windsor Restaurant. At the extreme left is the Sudden Death Saloon. Grandma Borsch tended the large garden, carrying water from the creek using a shoulder yoke and two pails. (Courtesy Chet Borsch.)

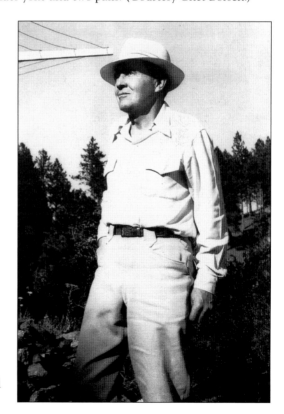

Fred Borsch Jr. was born in Galena and was a lifelong resident interested in local history. In 1947, he was given a pet coyote, which he named Tootsie. Tootsie and Fred were inseparable. She was "officially decreed" to be South Dakota's representative state animal and rode in many parades during her lifetime. (Mildred Fielder photograph, 1960s.)

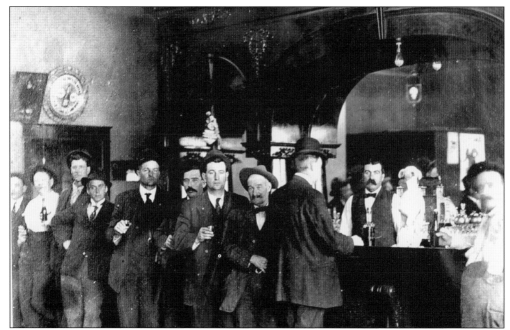

This is happy hour at one of Galena's prosperous-looking saloons. The natty gents are enjoying their shots of whiskey while the working men on the left are content with beer. The stag affair may be a salesman's "convention." The begging dog on the bar does not seem to be particular about a beverage choice. This picture was probably taken in the early 1900s.

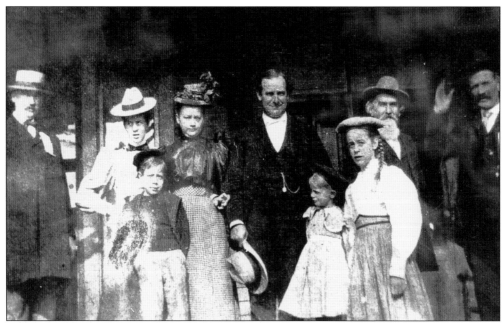

The William Jennings Bryan family is photographed in Galena in 1890 by Peterson Studio of Deadwood. The man on the left is unidentified but is wearing some sort of badge. The bearded man on the right is Dr. Daniel W. Flick. Waving to the camera is Sol Star, prominent Deadwood businessman. Bryan, of Nebraska, made an unsuccessful bid for president of the United States.

Seven

DAYS OF '76

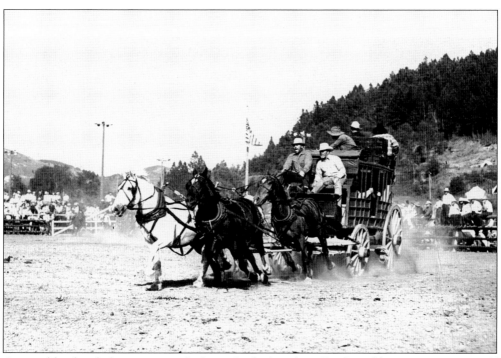

Actions like this dashing stagecoach chase clearly show how Deadwood keeps reinventing itself over the years by keeping its colorful past alive. Everybody loves the Wild West, making the area a must-see destination for fans of that historical time. In 1924, Deadwood held its first Days of '76 celebration, a summer tradition that continues to draw large crowds of spectators.

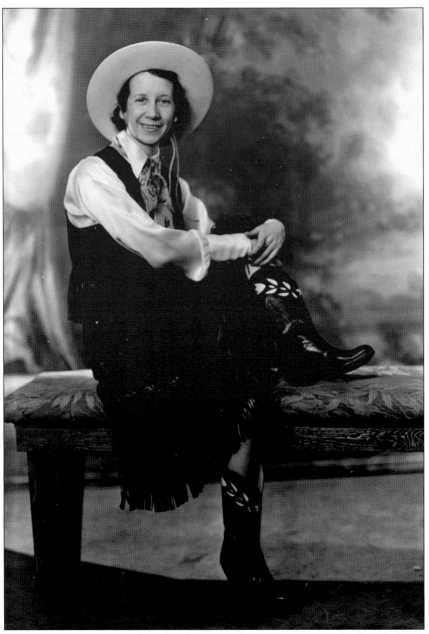

Nell Perrigoue, secretary of Deadwood's chamber of commerce, is credited with keeping the town's Old West image alive by creating "permanent" local characters who became great publicity resources. Perrigoue was also instrumental in getting up the first Days of '76 cavalcade of events and also helped to found the popular *Trial of Jack McCall*, still performed by townsfolk nightly during each summer. The committee for the inaugural Days of '76 weekend, August 15 and 16, 1924, consisted of Earl B. Morford, manager; W. A. Remer, parade chairman; and Fred Gramlich and A. A. Coburn, committee. The parade was three miles long. In 1927, Pres. Calvin Coolidge was awarded a ceremonial American Indian headdress by Chauncey and Rosebud Yellow Robe. Perrigoue's brother, Ned, was a professional photographer for Bell Studio (as was Bill Groethe), and over the years, the firm produced tens of thousands of postcards for the tourist industry.

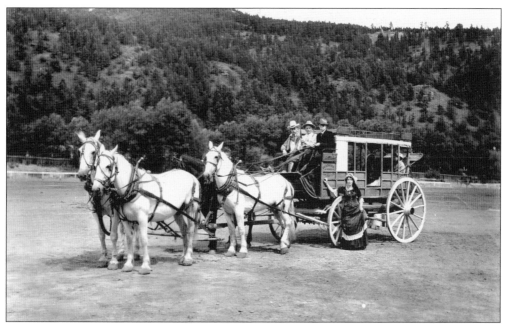

The old Spearfish to Deadwood stage is being piloted by its original driver, John S. McClintock (whose name is visible below the driver's seat), at Days of '76 in 1932. From left to right are Bill McLaughlin, Tony Bartalino, John S. McClintock, and Pat Woods, who worked with Nell Perrigoue on many events in the 1930s.

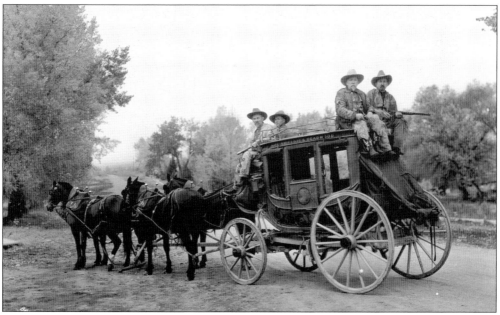

This Abbott-Downing Concord stagecoach was luxury transportation for passengers to and from the Black Hills. Painted bright red with yellow wheels and pinstriping, it had cushioned leather seats and leather braces on the undercarriage that gave a gentle rocking, rolling ride over the worst of roads. After being exposed to the elements for years in a city park, this coach was completely restored and placed on display at High Plains Heritage Center in Spearfish.

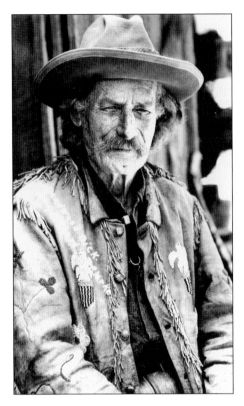

Richard Clarke was one of several characters over the years to use the soubriquet of "Deadwood Dick," but he is the one most associated with the legend. Clarke ranched around the area for some time and, being something of a braggart and showman, seemed perfect for the role. In the late 1920s, he and a party of tourism boosters flew around the country, even stopping to see President Coolidge at the White House.

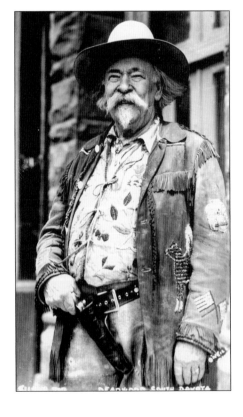

Another of Deadwood's colorful summer residents was Tom Grant, known as "Silver Tip." Deadwood's boosters were well aware of the good will and publicity these men generated for the community, and these colorful characters became famous in their own right by showing up in family photographs passed down through generations.

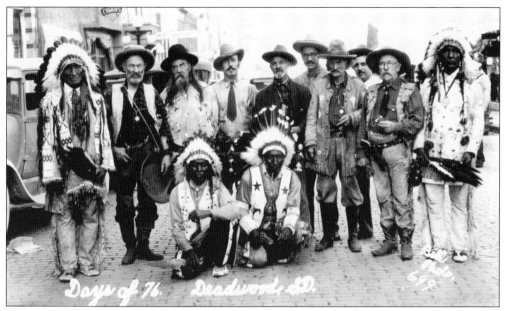

Who wouldn't want to have their photograph taken with these legends? Several hundred American Indians from the Pine Ridge reservation came to the festivities, and an early news release bragged that "every Indian will come mounted unless too old to sit a horse."

Potato Creek Johnny sits with his familiar miner's wheelbarrow. The elfish Welshman first worked as a wrangler for the Dorsett ranch on the Redwater River. He turned to prospecting, liked to drink, and told tall tales to tourists. Johnny was a familiar face in Days of '76 parades. Rumor has it that he was a worse than awful fiddle player and did not smell too well.

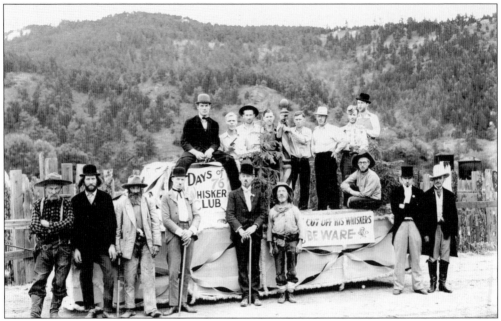

Here are a few of the members of the Whiskers Club. The *Pioneer Times* said, on July 25, 1924, "Deadwood is in the throes of an unprecedented epidemic of chin foliage," and that "Last evening it was estimated that at least 150 members had enrolled in the club and had pledged themselves to do their best to make Deadwood's whiskers crop one of the marvels of the world."

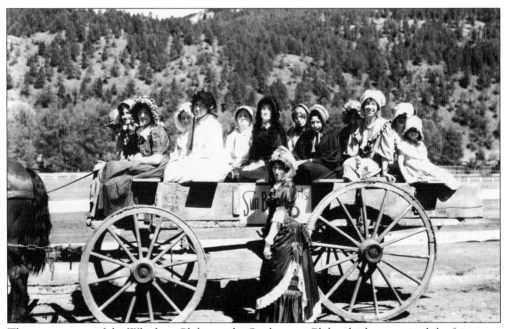

The counterpart of the Whiskers Club was the Sunbonnet Club, which comprised the fairer sex, of course, but was no less in evident at Days of '76 doings. Women of refinement were scarce in the mining camps of old, and when they arrived on the scene, they made their presence known. Mail-order brides were not unheard of in this part of the untamed country.

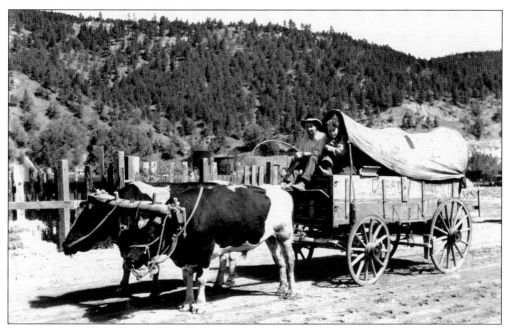

Oxen made excellent beasts of burden for the pioneer. Some were shod, but others sometimes got sore feet. Drover Peter Duhamel, an early Black Hills resident, found he could make them sound again by searing the bottom of their hooves with a hot iron and, by trading a sound animal for several lames ones, became a prosperous businessman.

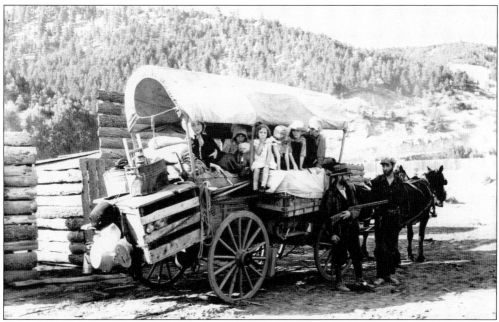

Traveling to a new life became an ordeal for families who wished to bring their worldly possessions with them. Pigs and chickens oinked and squawked, and many a pump organ or large piece of furniture was left behind on the trail when the going got tough. These reenactments have created an authentic representation of Deadwood's early times.

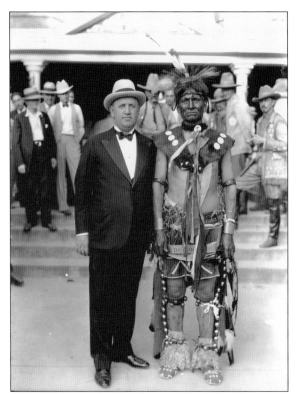

While American Indians much preferred the plains to the hills, they nevertheless enjoyed attending Days of '76 celebrations in all their finery. So many wished to participate that first year that newspapers reported Indian Committee chairman Ed Rentz "has made arrangements for the reception of additional Indian groups." The American Indians joined parades, danced, and took an active part in the races and rodeo events.

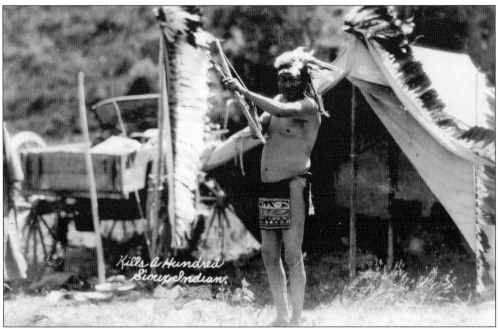

Kills-a-Hundred and his band of 300 American Indians came to participate and share the Lakota culture with visitors from all over the world who descended on Deadwood. Ed Rentz, who was in charge of the delegation, was once a member of Pawnee Bill's Wild West Show. When Rentz came to the area, he also served as a police officer and deputy sheriff.

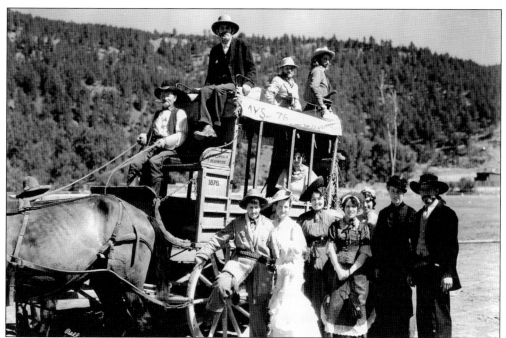

It seemed everyone in Deadwood wanted to be part of the town's early history. Impersonators of Calamity Jane and other notables often went to celebrations in other Hills towns to act as ambassadors of good will and also to drum up some advertising of their own.

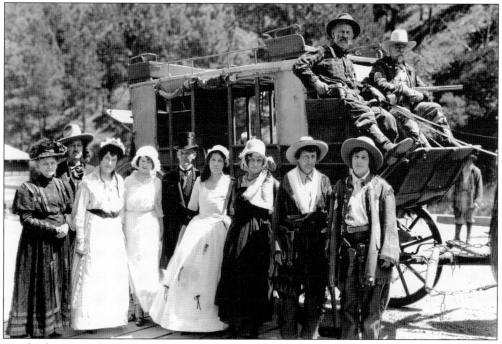

Besides horses and riders in period attire, Deadwood's Days of '76 has boasted one of the best vintage horse-drawn collections of buggies and wagons to be found anywhere. They are featured prominently in the annual three-mile-long parades and in Deadwood's Days of '76 Museum.

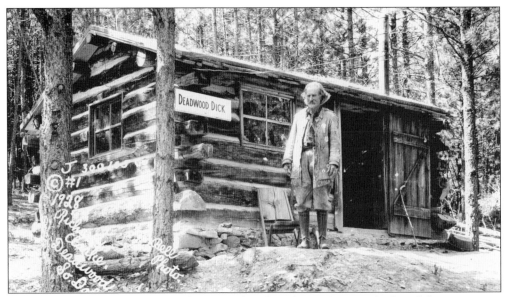

Deadwood Dick Clarke is at his cabin near the edge of Pine Crest Park. City fathers saw great advantage in providing Clarke with this rustic abode adjoining the tourist camp, where he regaled folks of all ages with his stories, dressed in fringed buckskins. John S. McClintock called him an imposter, but he may, in truth, really have been a Pony Express rider, as records show a Richard Clarke as an employee. Clarke died in 1930.

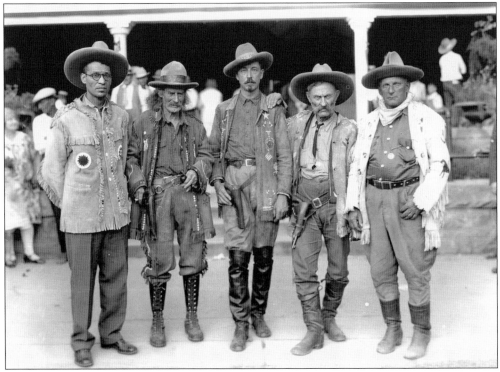

These fellows would make a good welcoming committee whether or not there was a celebration going on. A pretty handsome group they are, too.

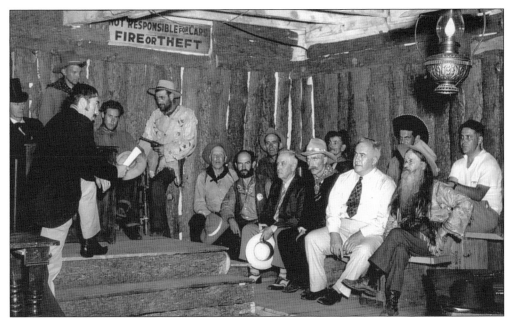

A popular attraction for many years, the *Trial of Jack McCall* is performed by local actors. McCall, accused of killing Wild Bill Hickok, is tried nightly by Kangaroo Court during the summer. Unsuspecting persons from the audience are called to serve as members of the jury, and Judge Kuykendall presides over the trial. McCall was acquitted, but in 1876, he bragged of his deed in Cheyenne, was taken to Yankton, Dakota Territory, the territorial capital, and hanged.

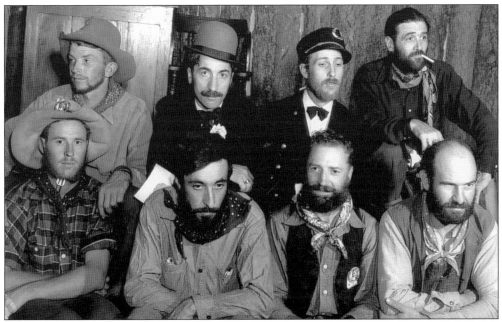

These men played the roles in the 1930s of those who took part in the original trial of McCall held in the Gem Theater in 1876. Gale Wyman, a member of the Whiskers Club, tried the assassin in the later spoof. His grandfather helped to build the scaffold from which McCall was hanged in Yankton.

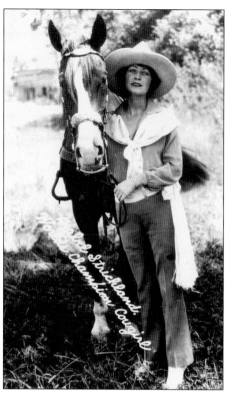

There was something about a horse that attracted beautiful ladies. Mabel Strickland, pictured here, was a world champion cowgirl in the 1920s. Women often competed in events such as riding bucking broncos, relay racing, and performing trick-riding stunts, without ever smearing their makeup.

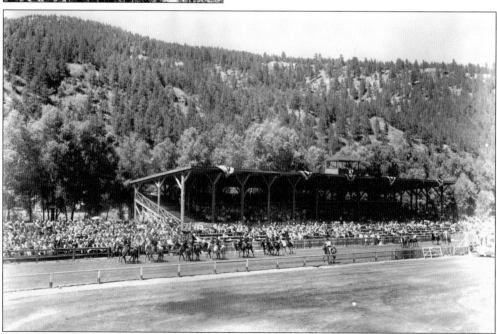

Deadwood's Rodeo Grounds lie in the basin of Spruce Gulch at the south end of town. The main road to Deadwood for years ran through Spruce Gulch. Today a Days of '76 museum on the site adds to the celebration's rich history, where the city's fabled vehicle collection is on display, and PRCA-sponsored professional rodeos are a popular annual attraction.

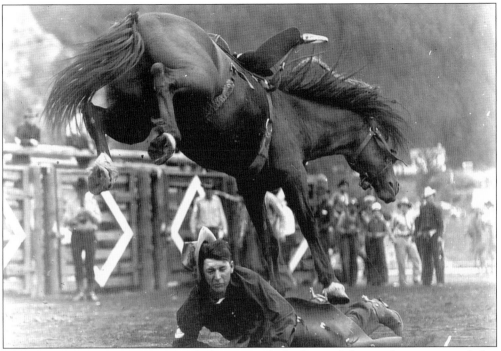

Rodeo action is fast and furious on the hurricane deck of a tough bronco but not so much fun when one is on the bottom looking up.

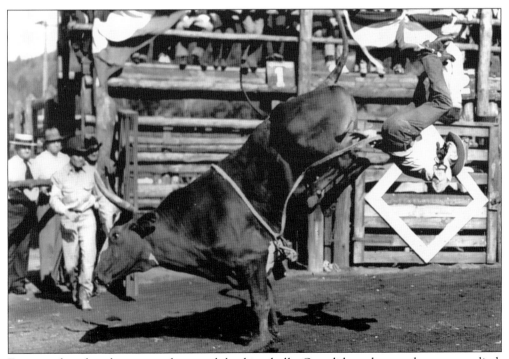

Even tougher than horses are these rank bucking bulls. One did not have to be crazy to climb on, but it probably helped. Many of the nation's top riders try their luck here.

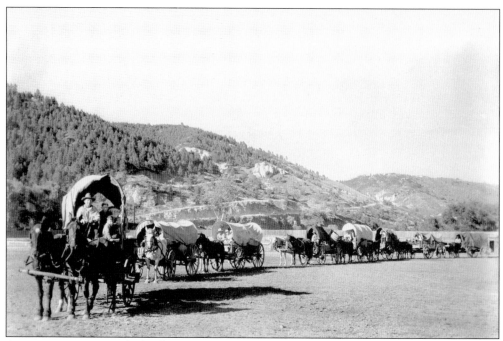

A wagon train gets ready for the grand entry at the Days of '76 Rodeo in the late 1920s. All of the horse- and mule-drawn vehicles used during these early days were authentic and made up one of the largest rolling history displays to be found anywhere.

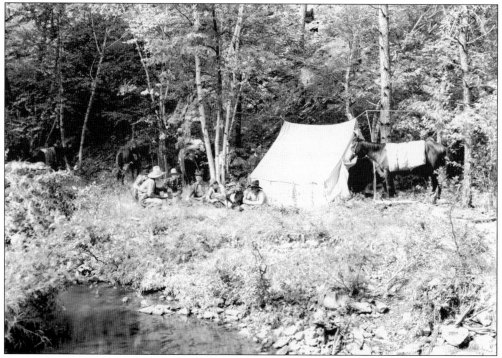

To get the full flavor of Deadwood's Days of '76, camping out in the Western tradition was the way to go. A little fishing, a campfire, and a trusty varmint rifle—life was good!

Eight

GHOST TOWNS AND ABANDONED PLACES

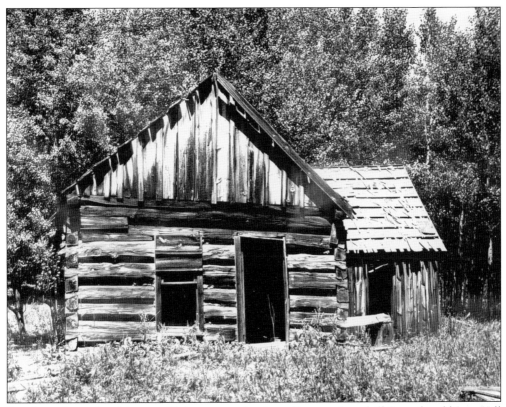

Raspberry Brown's cabin near Carbonate, and a short distance downhill from the old Iron Hill shaft, is slowly turning to dust in this 1964 photograph taken by Mildred Fielder. Traveling Black Hills back roads today may still turn up an abandoned building or two.

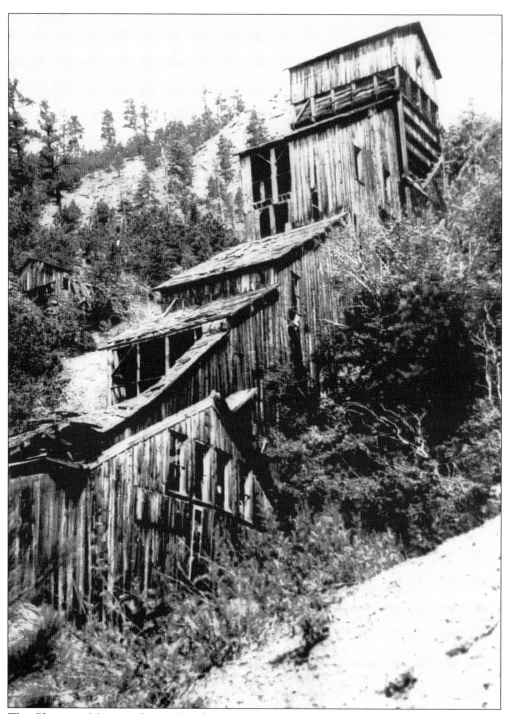

The Cleopatra Mine on Squaw Creek near Carbonate, built in 1886, is seen here. Men who worked at the Cleopatra obviously had to be in top physical condition, for stairs were up and down all sides of the mountain. This photograph was taken on August 15, 1954. One of the most spectacular of Black Hills mines, pioneering newspaperman Richard B. Hughes was an early backer, the Cleopatra only operated for 15 months.

This is the Belle Eldridge gold mine, which covered 110 acres in Spruce Gulch, one mile east of Deadwood (called the Mowee mine in the early 1900s). Lead and zinc were also found in the late 1890s. It had a small flotation mill producing lead-zinc and gold-silver concentrates. This 1960 photograph shows the crumbling remains. (Courtesy Homestake Mining Company.)

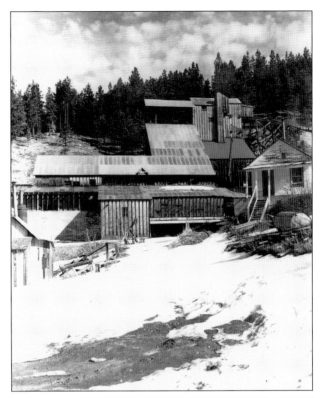

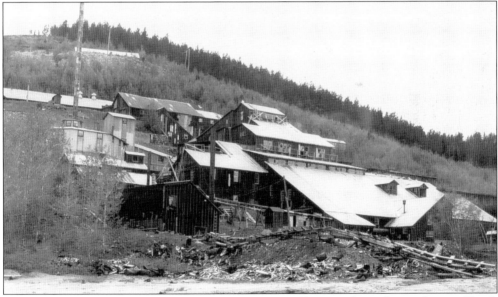

Seen here is the Bald Mountain Mining Company near Trojan, a few miles southwest of Lead. The Bald Mountain was the second largest gold mine in the United States (Homestake being the largest). Mine operations began in the 1870s and closed down in 1958. Claim jumping of smaller sites was still rampant in 1888, and hobos who followed the railroads were credited with providing needed labor in many of the larger operations. Mildred Fielder took this photograph for posterity in 1967.

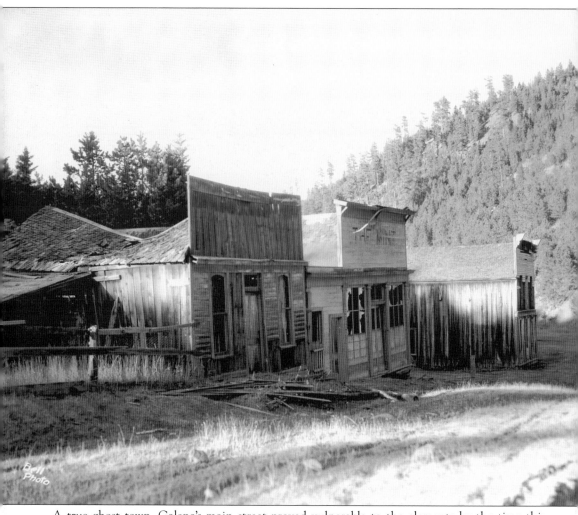

A true ghost town, Galena's main street proved vulnerable to the elements by the time this Bell photograph was taken around the late 1920s. At left are the ruins of Jim Conzette's cabin, the Windsor Restaurant, and the Mint Saloon. The Corner Saloon was at the end of the street where the road curved sharply to the left.

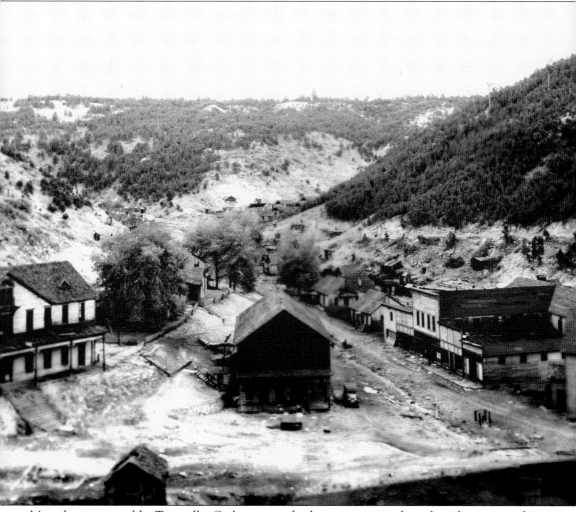

Many boom towns like Terraville, Carbonate, and others were situated on the sides or tops of the steepest hills, making any sort of travel and hauling a very difficult experience. These camps got the hottest sun, the strongest wind, and the bitterest cold. Since rain ran downhill, they also had the muddiest streets and routes to and from homes and businesses.

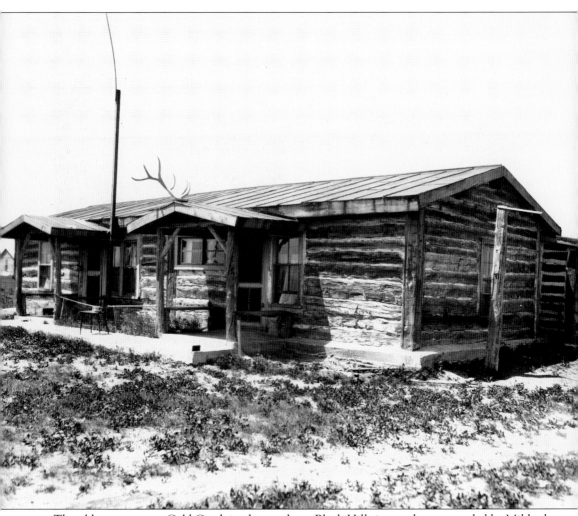

The old stage stop on Cold Creek in the northern Black Hills is seen here, recorded by Mildred Fielder in 1970. Oases in the unforgiving wilderness, two such noted locations were the Halfway House on the Deadwood-Spearfish route and the Cliff House, which served as a restaurant into the 1950s. In Western movies, many an ambush or robbery took place at these isolated spots.

Even higher than the town of Carbonate was its cemetery. Many of the markers placed on early graves were lovingly created by family or friends with materials available at the time. They remained in place until the elements wore them away. This ornate memorial is for John Tripp, who died in 1888, resulting from a fall down a mine shaft. (Mildred Fielder photograph, 1964.)

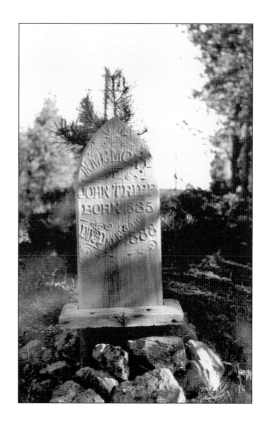

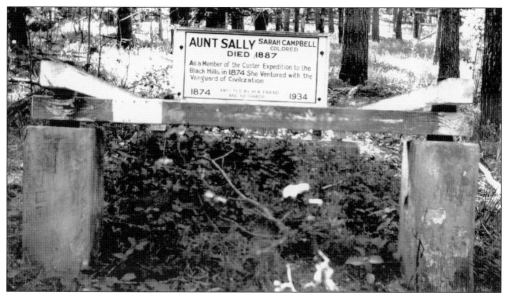

Sarah "Aunt Sally" Campbell was a cook who came along on the Custer's 1874 expedition to the Black Hills. Described as a "mountain of dusky flesh," she got gold fever like the others and filed a claim on French Creek near Custer City. Aunt Sally was the first known woman to arrive here. Her grave is in the old Vinegar Hill Cemetery in Galena.

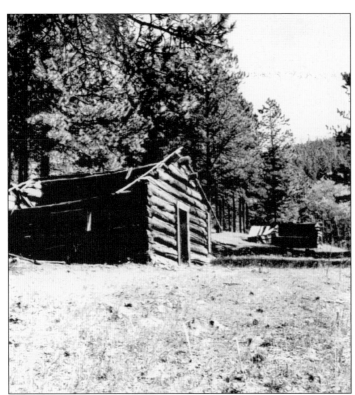

Here are the remains of Jim Morrisey's Lost Camp (Lost Gulch) cabin on Annie Creek near Trojan. He told the time of day by drilling holes in his wall as certain distances for the sun to reach, but it was not reliable on cloudy days. When Morrisey died in 1926, his nephew George built a second cabin made of railroad ties with a cement roof and floor. (Mildred Fielder photograph, 1956.)

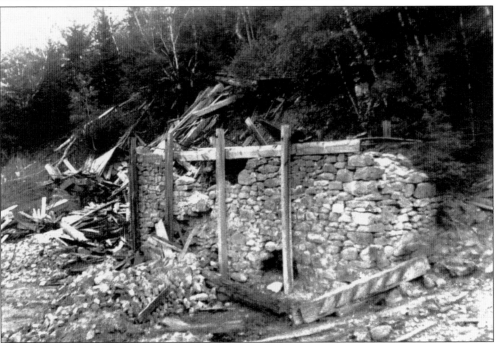

The remains of the old smelter at Rubicon Gulch are seen here, northwest of old Carbonate. There is not much left to demonstrate the activities once taking place for miles around. (Mildred Fielder photograph, September 15, 1958.)

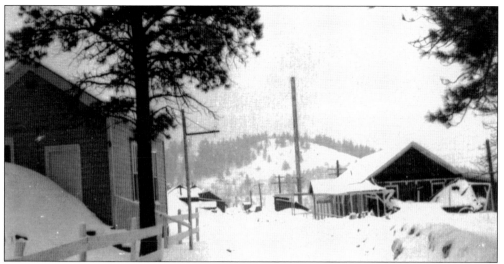

Trojan, earlier called Portland, was built on a stretch of Annie Creek and was anchored by the Bald Mountain gold mine. It was known as a company town, and families enjoyed life there—unlike neighboring Preston, which was called a "hell-roarin' place."

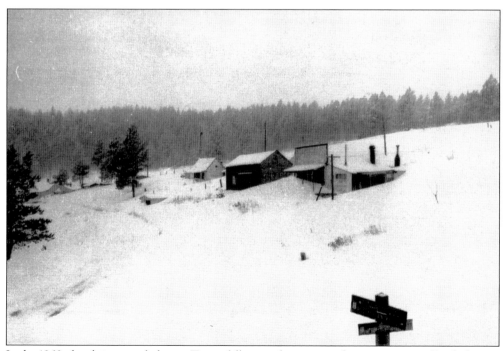

In the 1960s, hard times settled in on Trojan following the ceasing of mine operations. Bartholomew Trucano's Store is nearly engulfed by swirling snow. It dates to 1901, and members of the Civritto family delivered groceries to neighboring mining towns of Preston, Terry, and Gunnison.

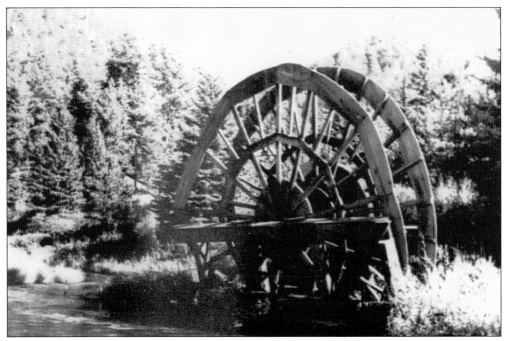

The wonderful old water wheel at Castle Creek above Mystic helped move gravel from the streambed to mining operations. Water was an absolute necessity in gold rush country. (Mildred Fielder photograph, 1964.)

Serene Potato Creek meandered within its banks with little attention until Johnny Perrett fished out a huge gold nugget that caused a great deal of excitement around Deadwood. Perrett's cabin was near this site photographed by Mildred Fielder.

A burro pack train is winding down the trail, signaling an end to one of the most interesting eras of American folklore and history.

GUESS I'VE BEEN OUT HERE TOO DANG LONG!!

This comic miner and burro postcard was still a popular theme for tourists vacationing out west, and was a little risque for 1957. (Fun Cards by Gad, Minneapolis.)

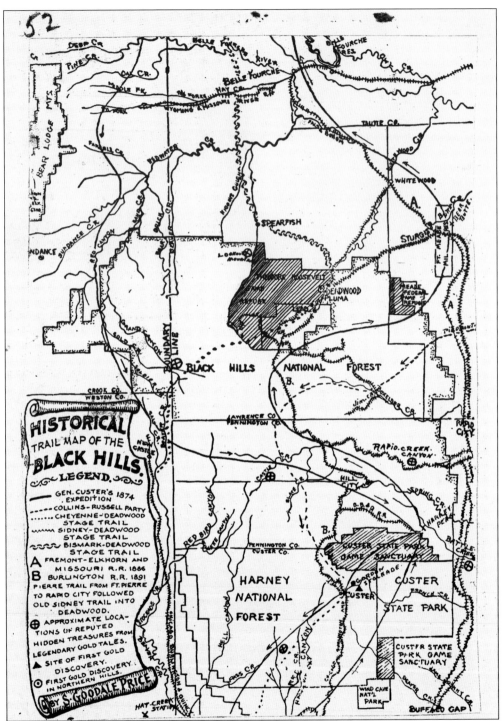

Looking back, this map of early Black Hills trails was drawn by S. Goodale Price in the late 1920s or early 1930s and shows the routes of Custer's 1874 expedition, stagecoach roads, railroad lines, and locations of the region's national and state parks. The Black Hills region is only 100 square miles, but it contains more legend than any place else in the American West.